Where Madness Reigns
The art of Gris Grimly

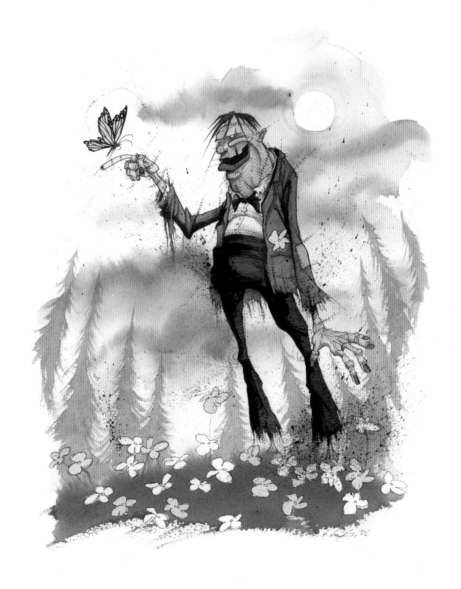

Baby Tattoo Books®
Los Angeles

(on previous page)

High Contrast
ink and watercolor on watercolor paper 2006

ISBN: 978-0-9778949-8-7 Trade Paperback
ISBN: 978-0-9793307-8-0 Limited Edition Signed Hardcover

First Edition

10 9 8 7 6 5 4 3 2 1

Published by Baby Tattoo Books®
Los Angeles
www.babytattoo.com

Design by Laurie Young

Manufactured in China

Rise Gut Tongue Rise
ink and watercolor on watercolor paper 2006

Where Madness Reigns
The art of Gris Grimly

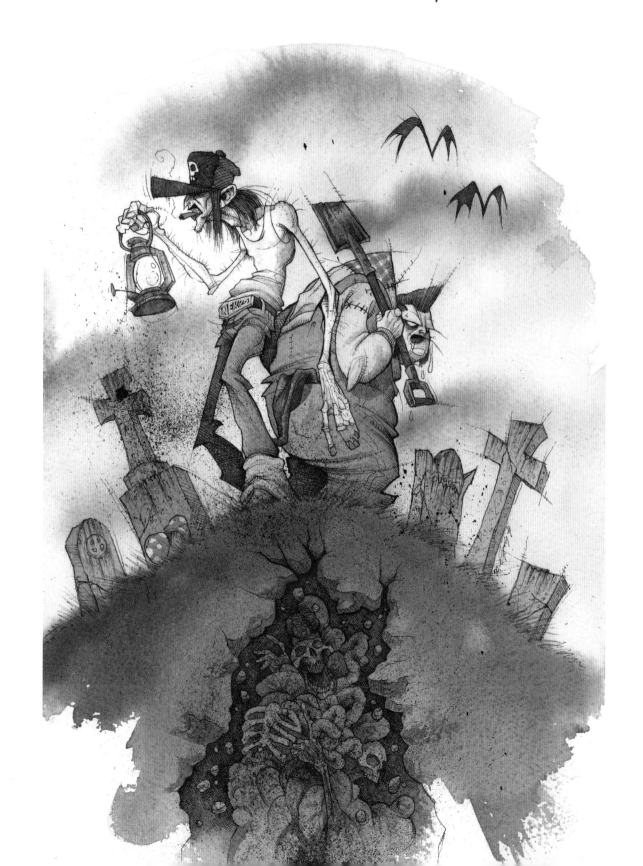

Bop Pills
mixed media on canvas 2007

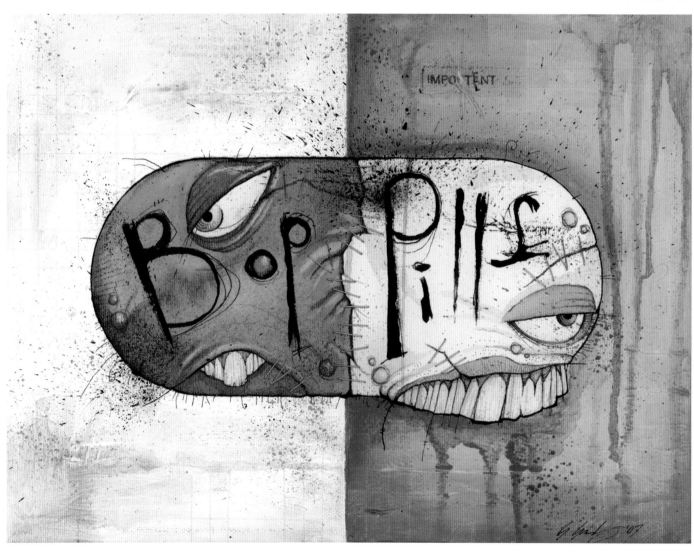

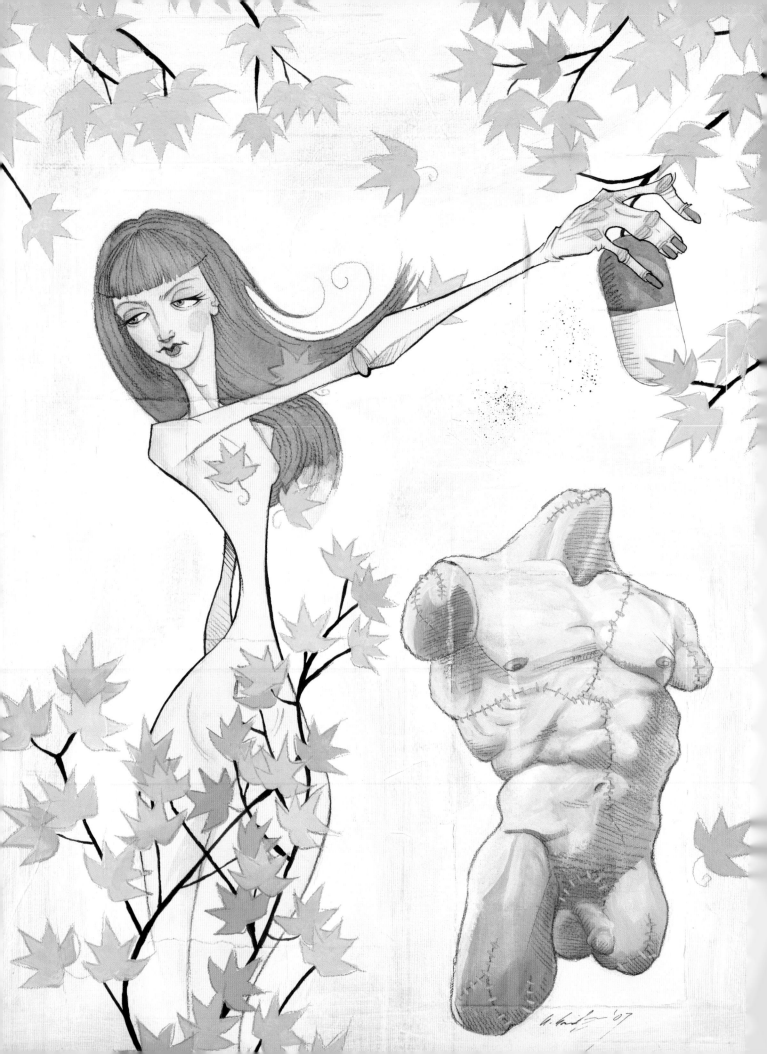

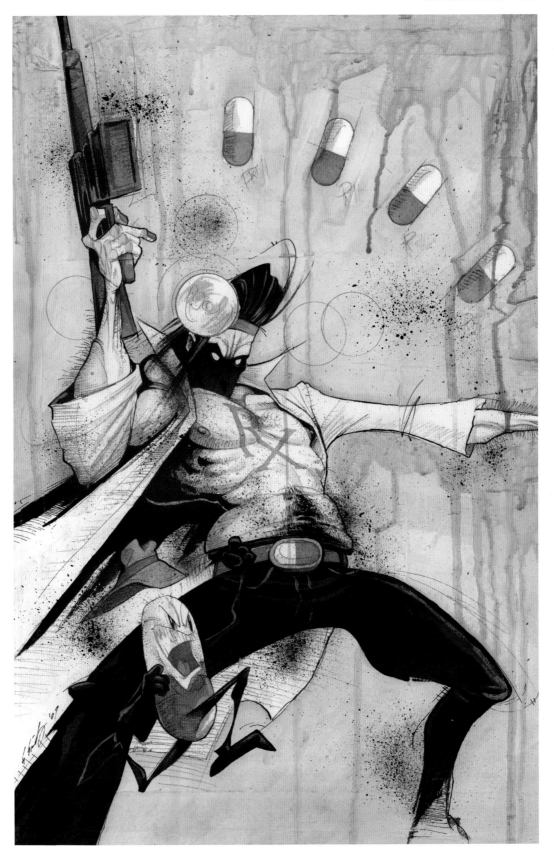

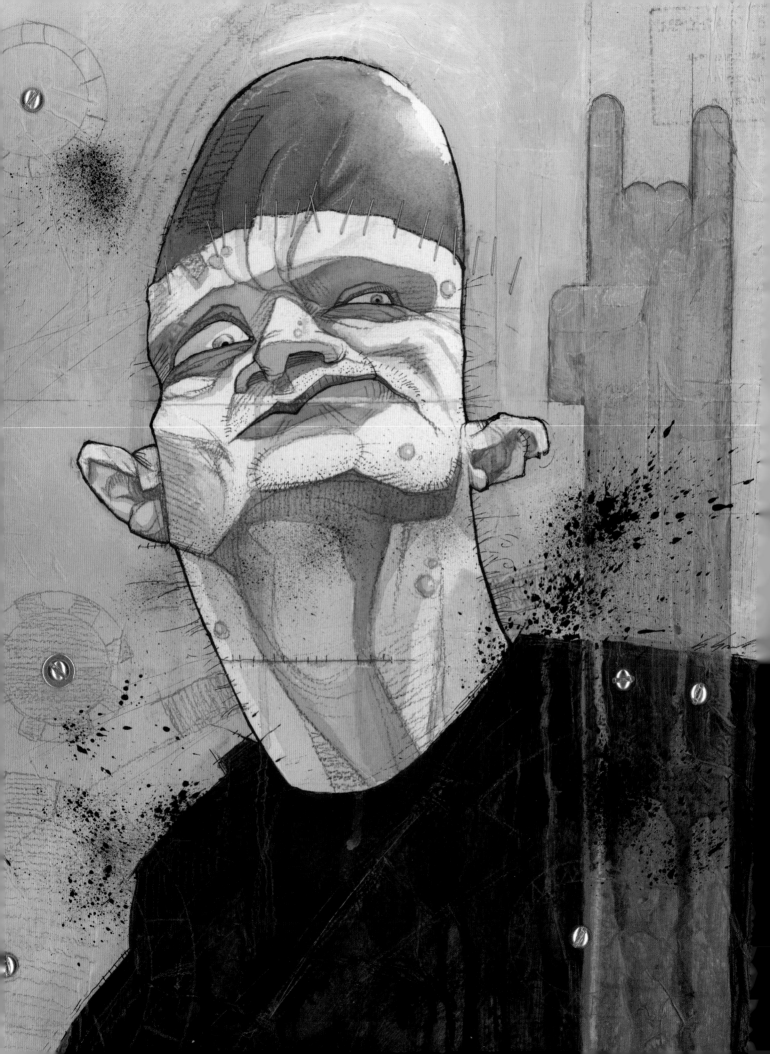

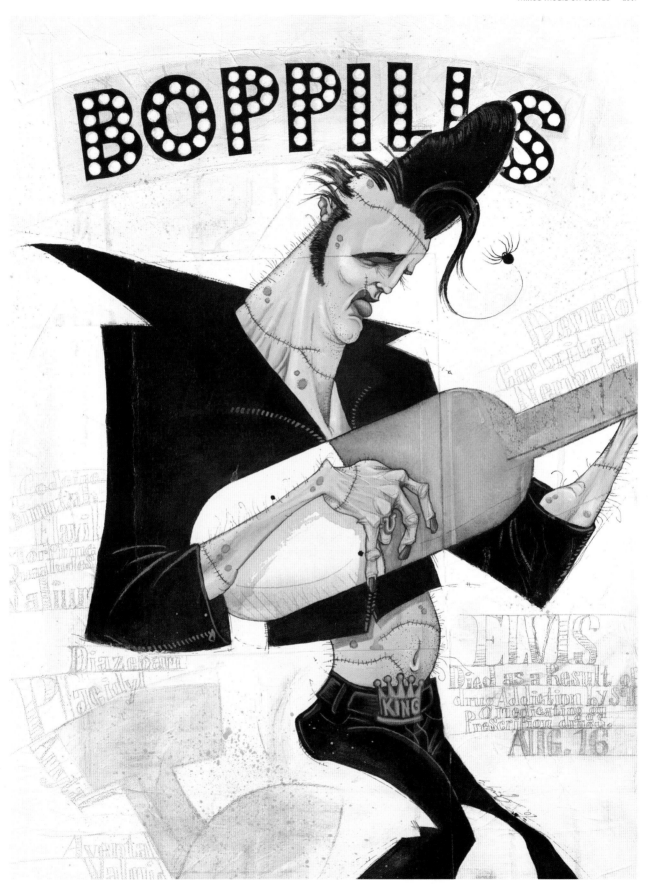

Pill Head
mixed media on board 2007

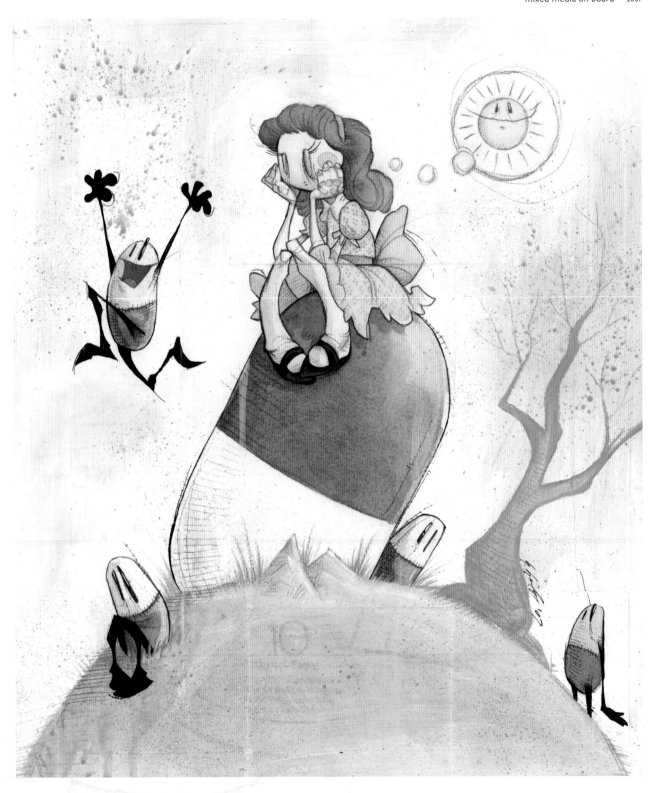

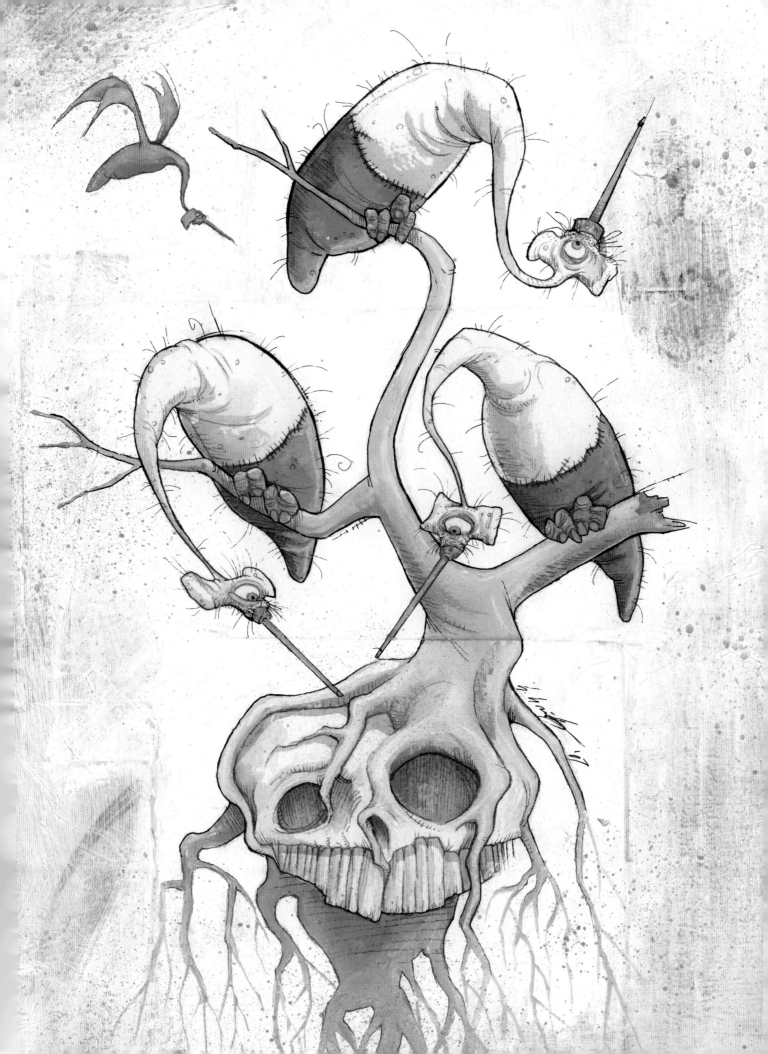

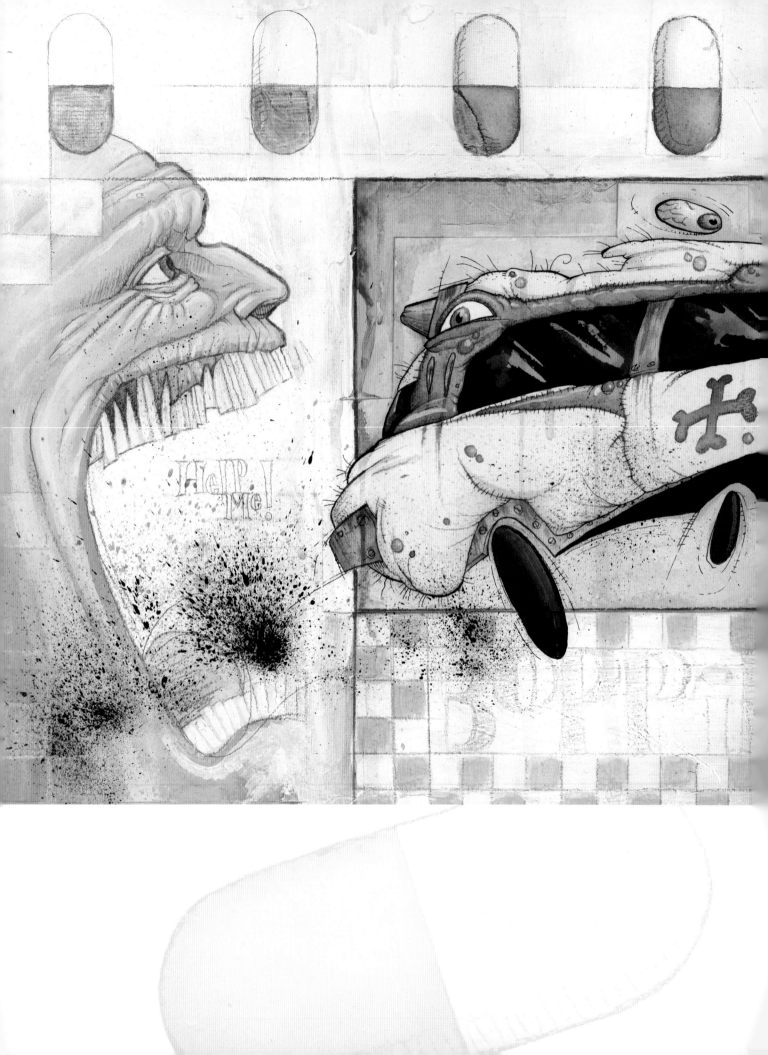

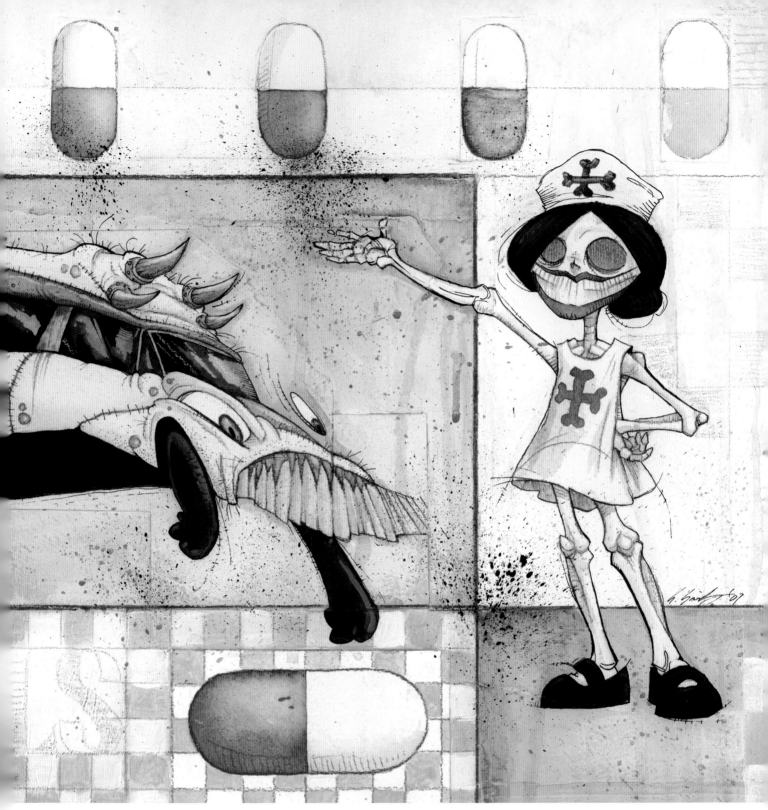

Pharmaceuticals to the Rescue
mixed media on board 2007

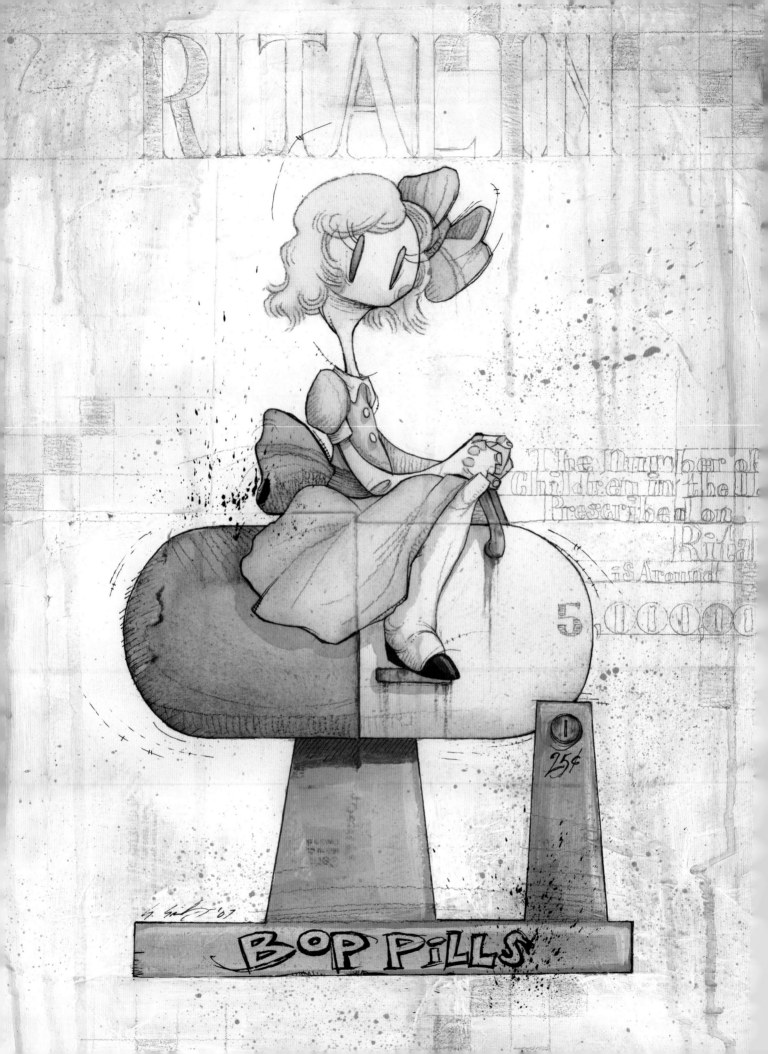

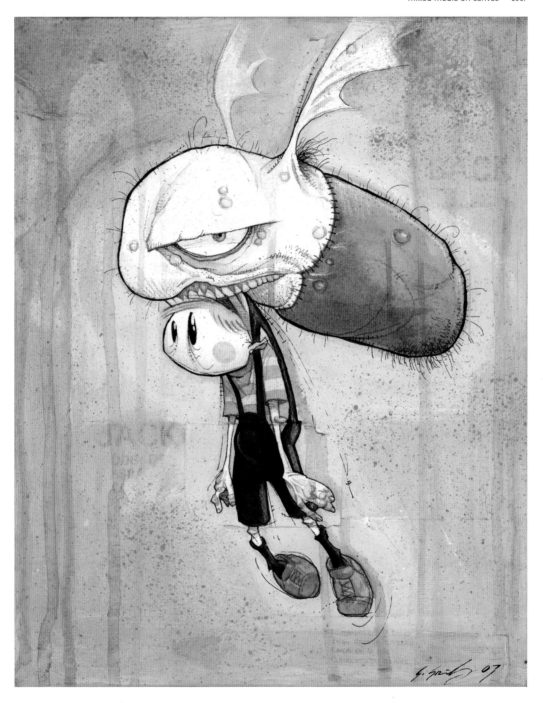

Ride of your Life
mixed media on board 2007

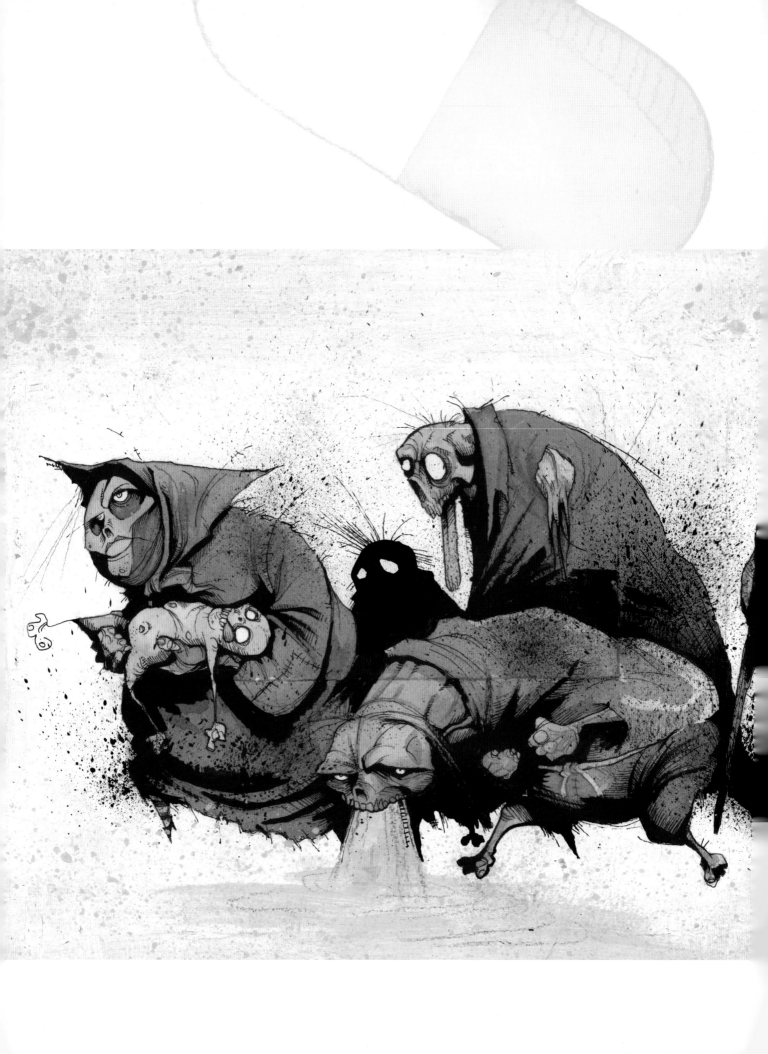

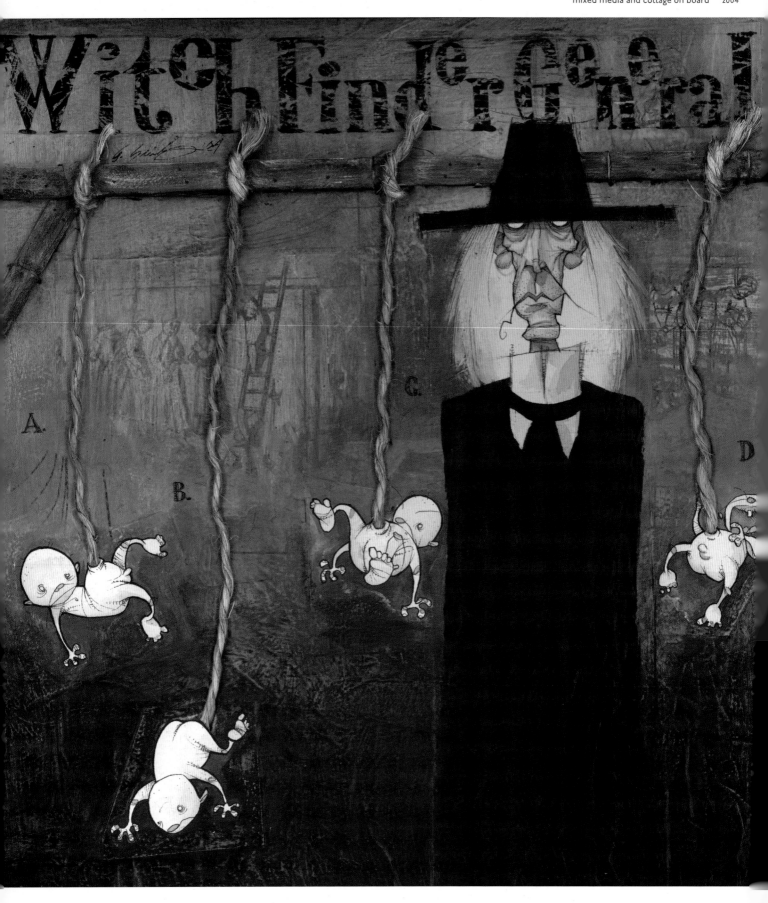

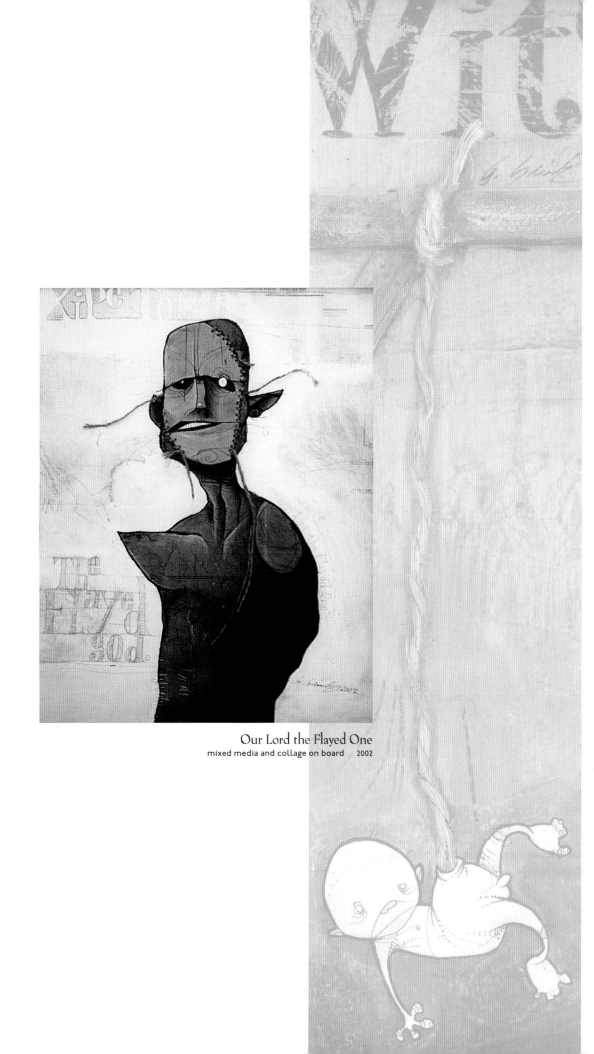

Our Lord the Flayed One
mixed media and collage on board 2002

Don't Worry, your Child's with Me at the Tea Party Doing Coke with Bugs Bunny and Abe Lincoln
mixed media and collage on board 2006

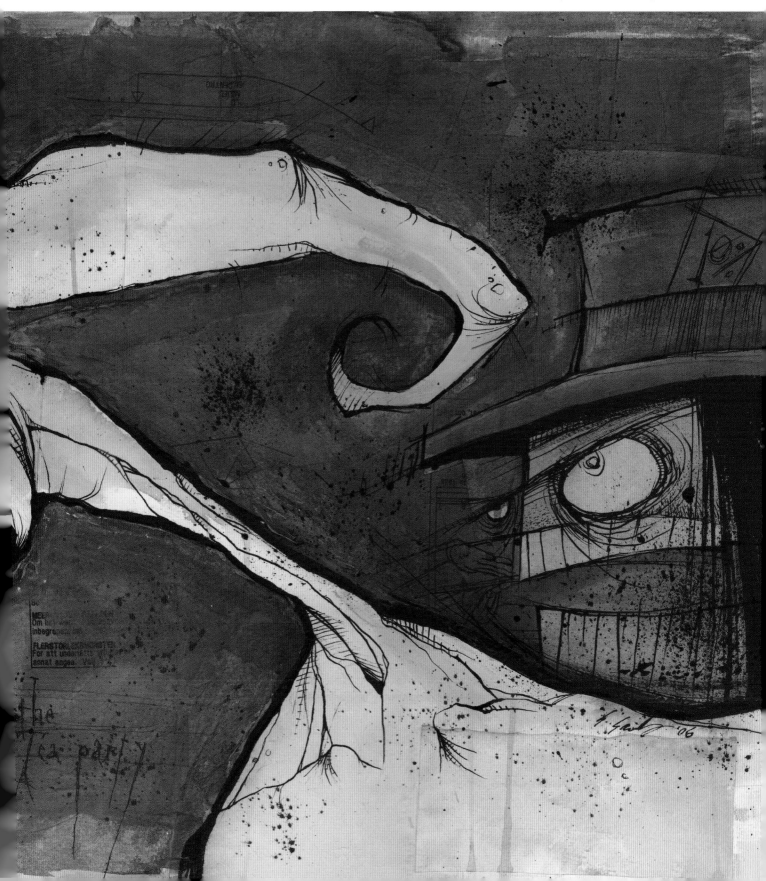

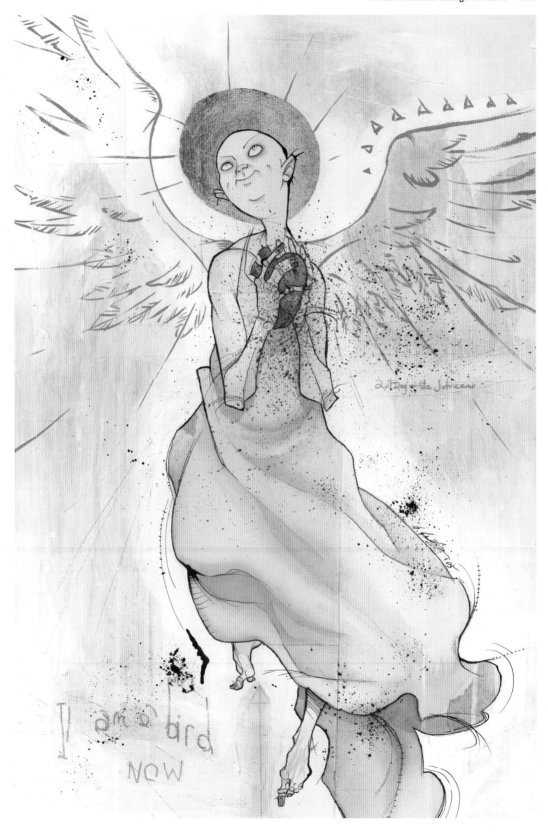

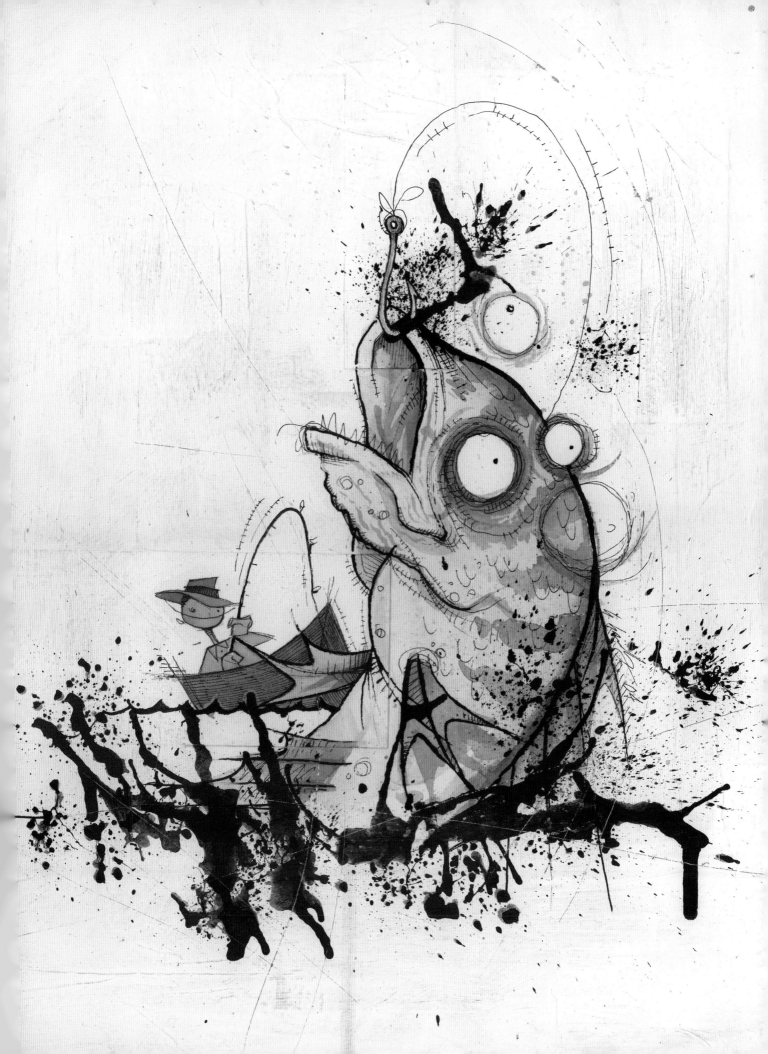

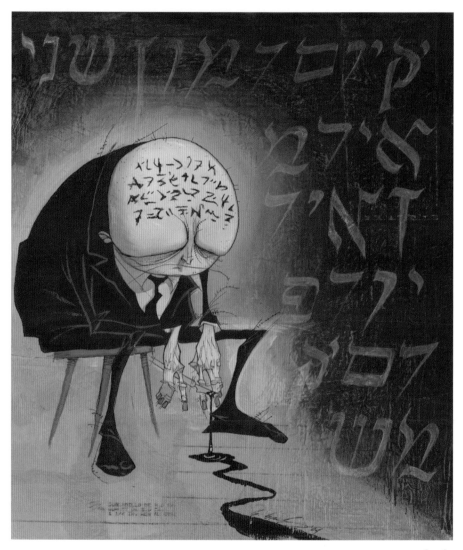

How to Disappear Completely
mixed media and collage on board 2004

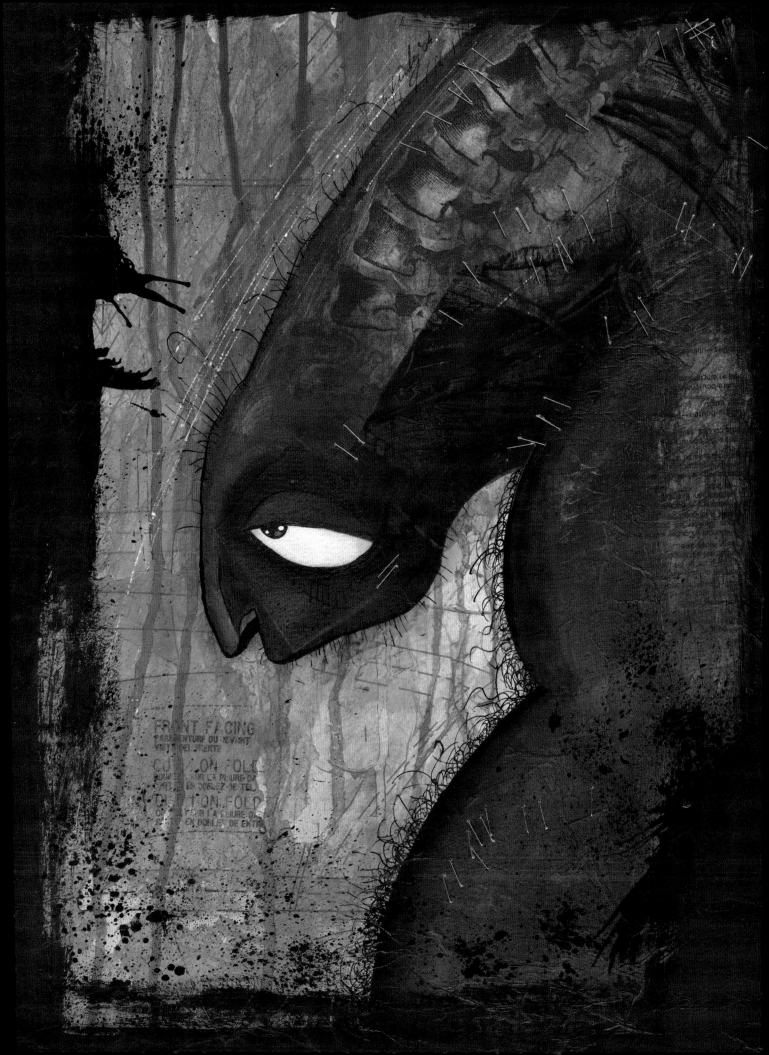

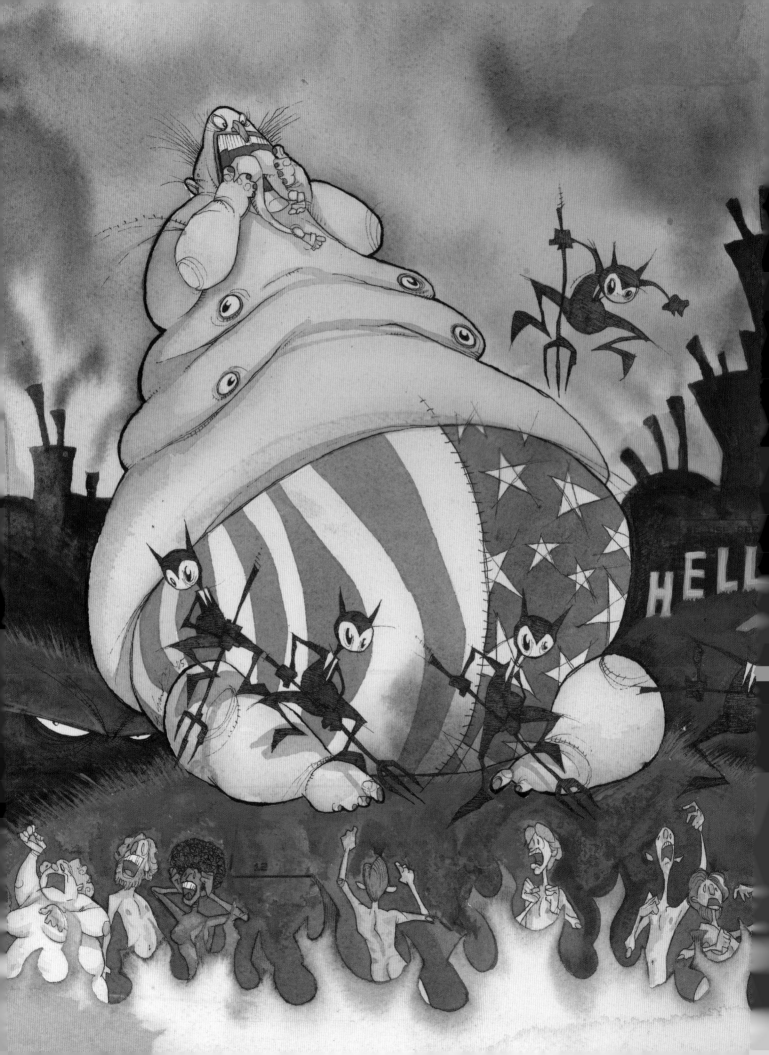

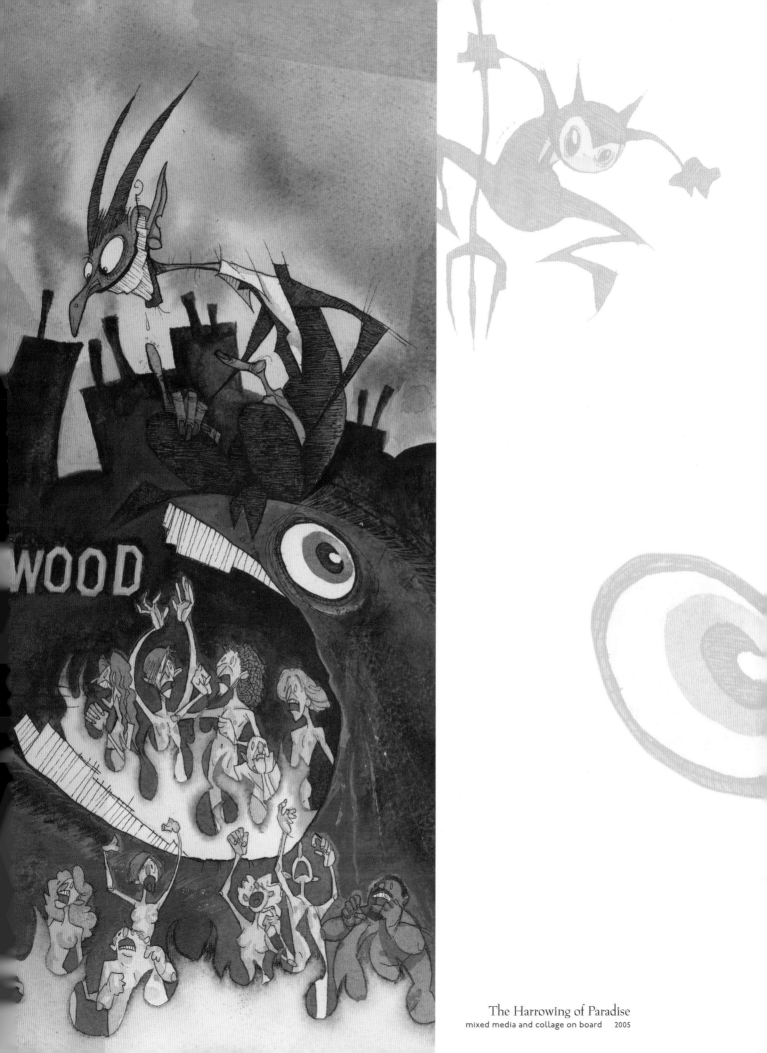

WOOD

The Harrowing of Paradise
mixed media and collage on board 2005

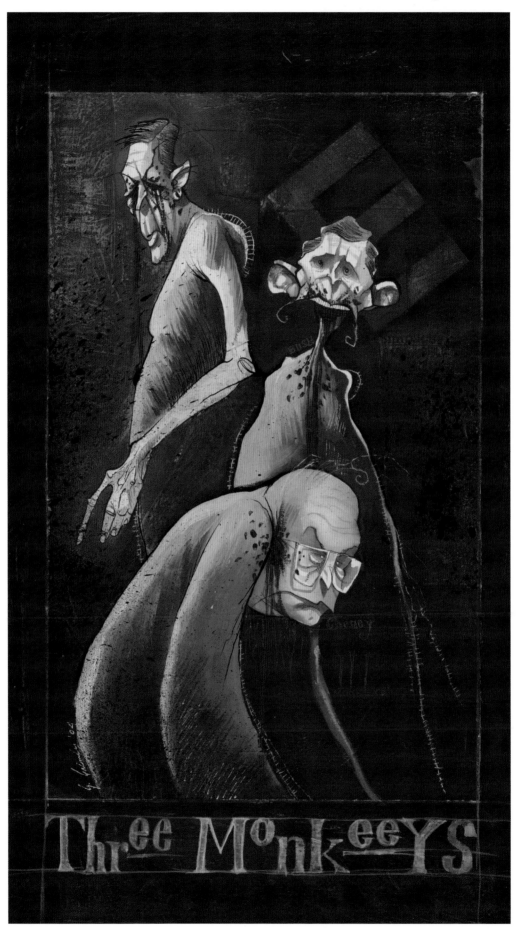

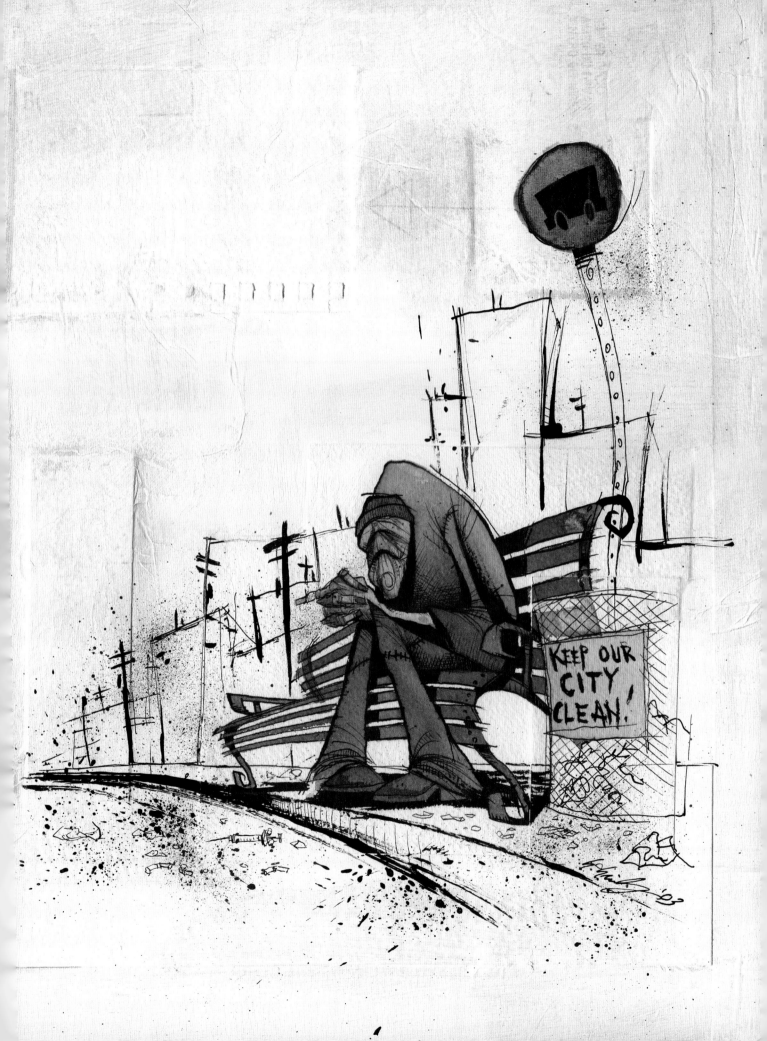

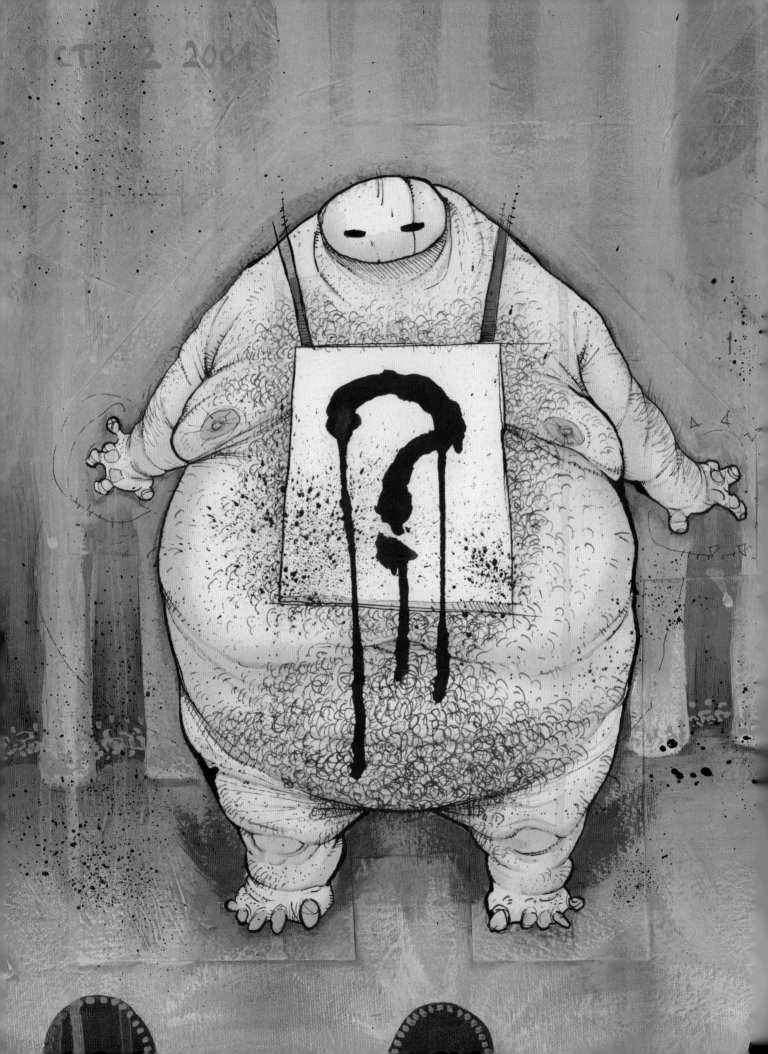

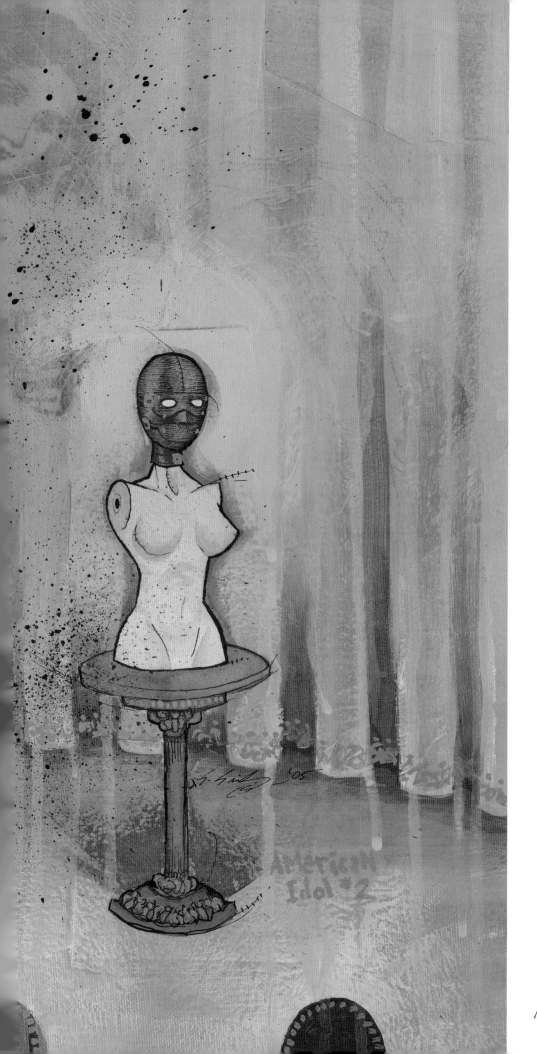

An Ode to the Modern Anomalies

mixed media and collage on canvas 2005

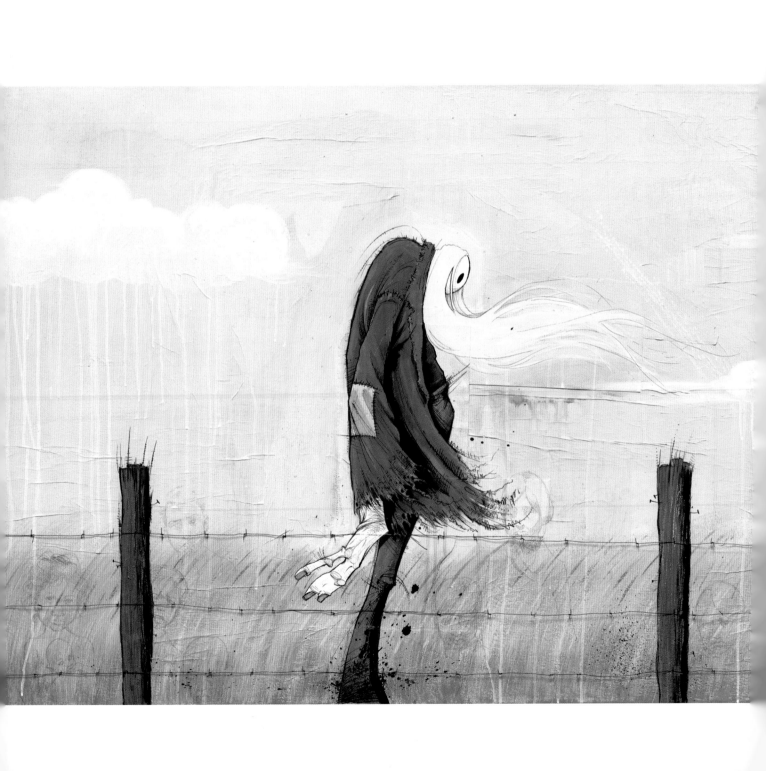

The Thing on the Side of the Road to Nowhere
mixed media and collage on canvas 2006

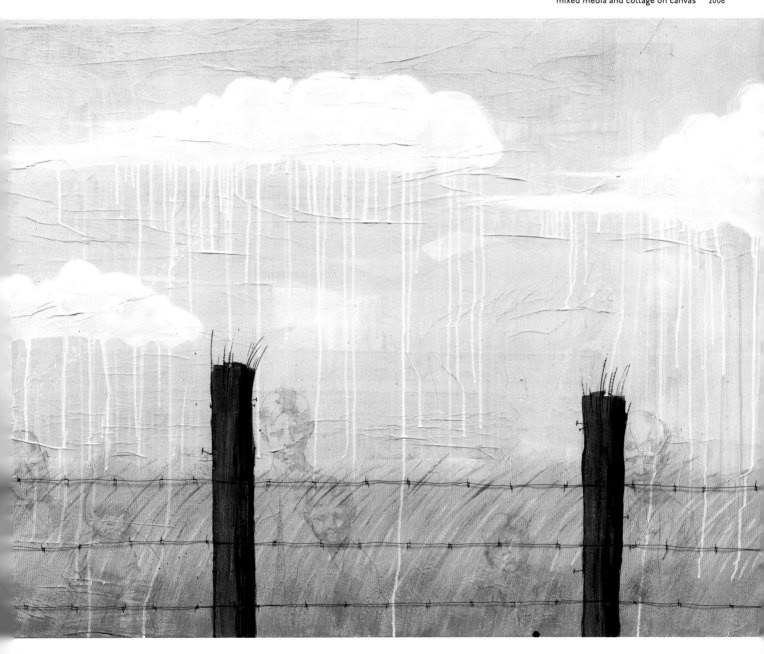

The Weeping Song
ink and watercolor on watercolor paper 2003

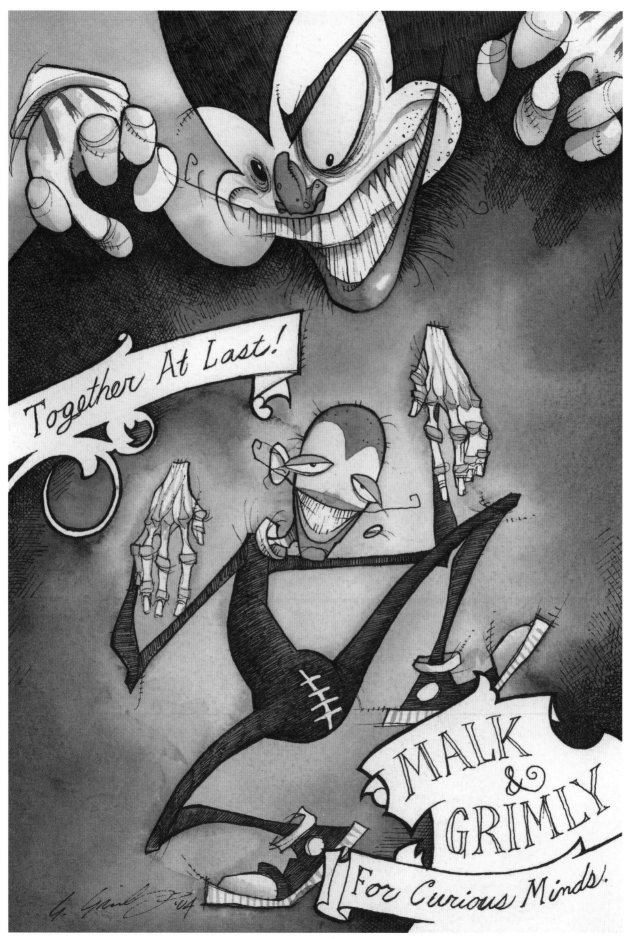

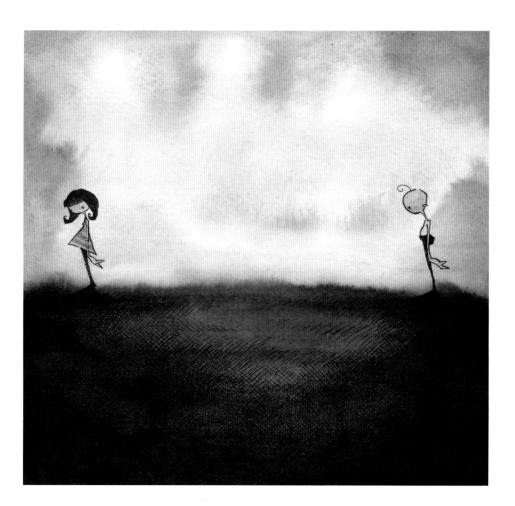

Apart
ink and watercolor on watercolor paper 1999

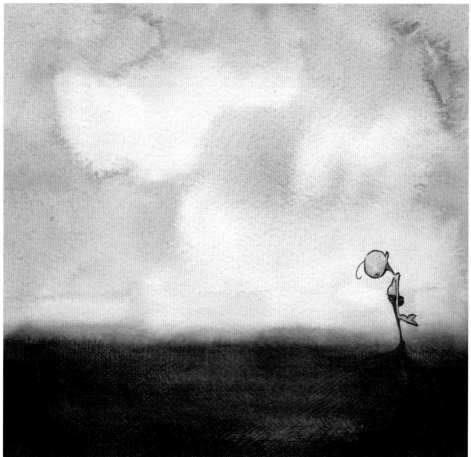

Alone
ink and watercolor on watercolor paper 1999

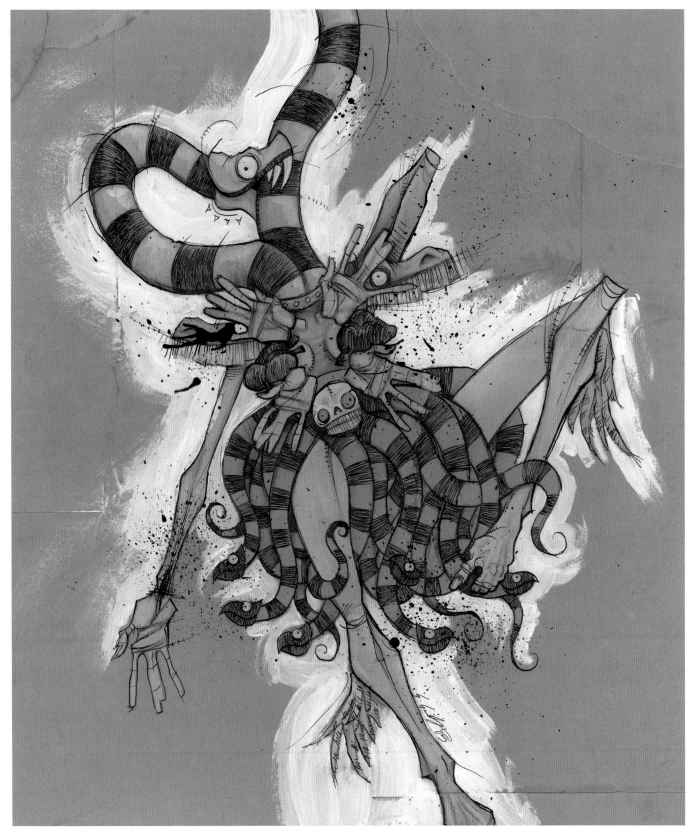

The Birth and Death of Everything
white acrylic and ink on gray paper 2005

The Customary Birthday Fish
white acrylic and ink on brown paper 2004

Goddess of the Creeps
white acrylic and ink on gray paper 2002

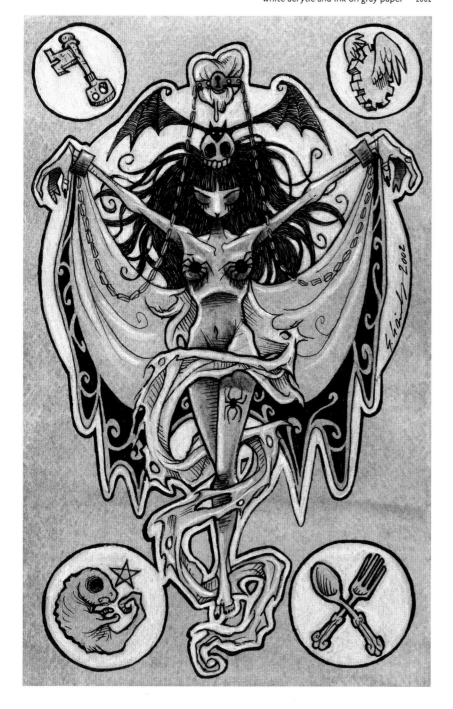

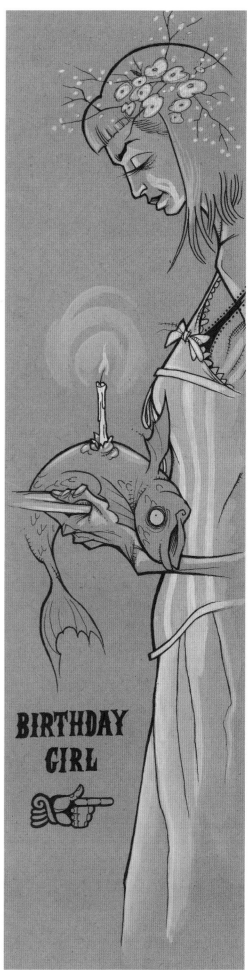

BIRTHDAY
GIRL

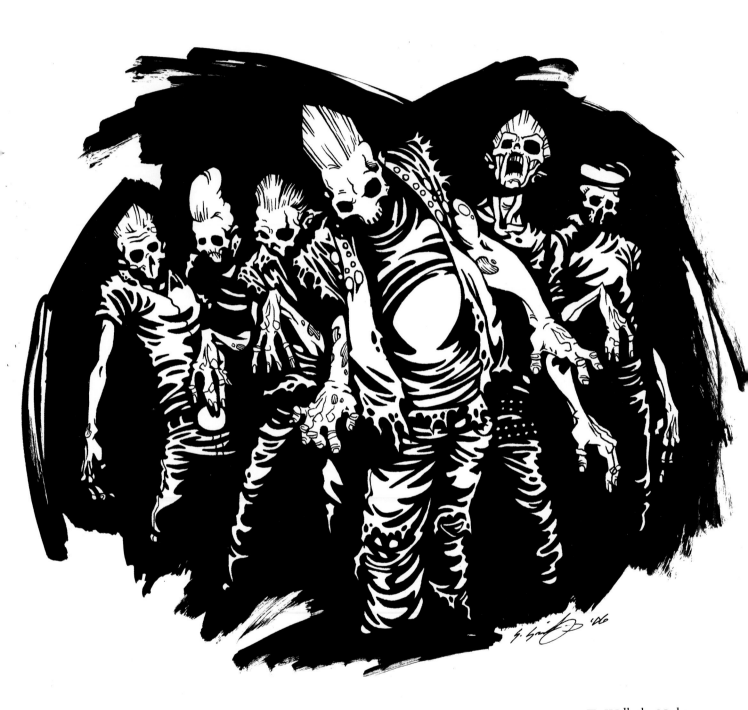

To Walk the Night

ink on illustration board 2006

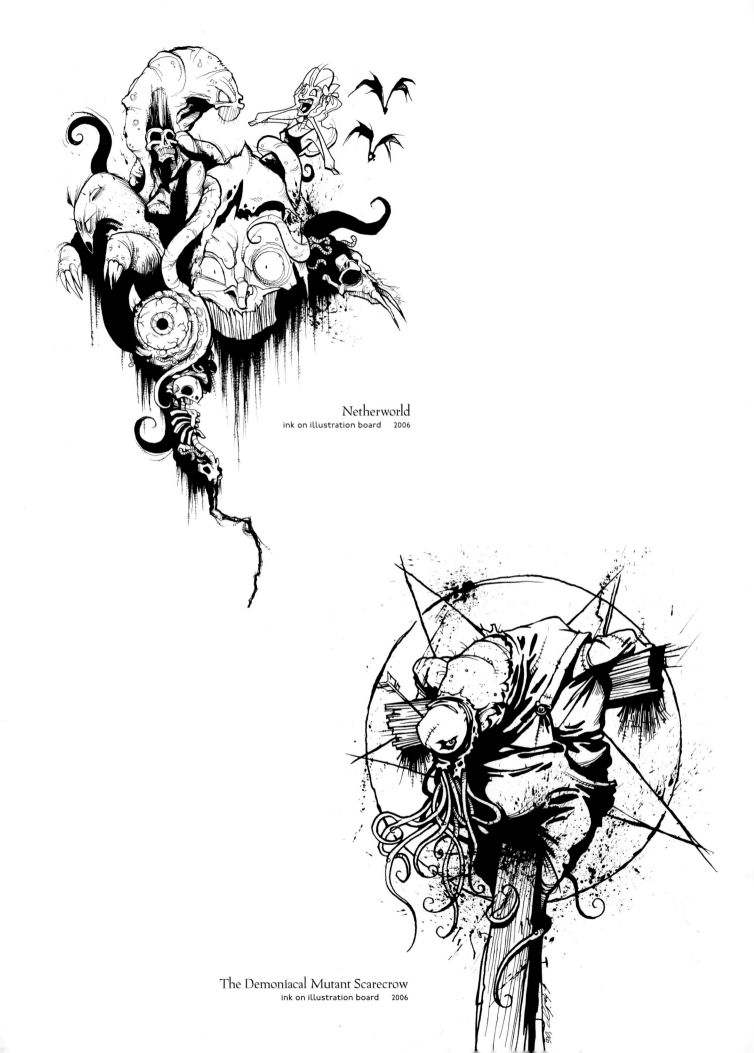

Netherworld
ink on illustration board 2006

The Demoniacal Mutant Scarecrow
ink on illustration board 2006

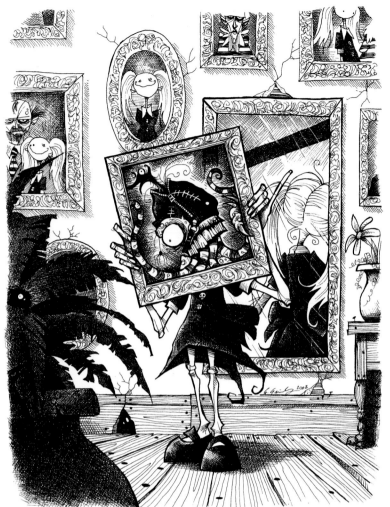

Ugly Girl in a Pretty Frame
ink on illustration board 2002

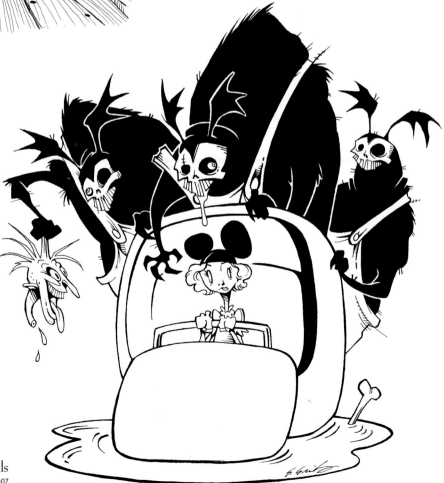

Welcome Foolish Mortals
ink on illustration board 2007

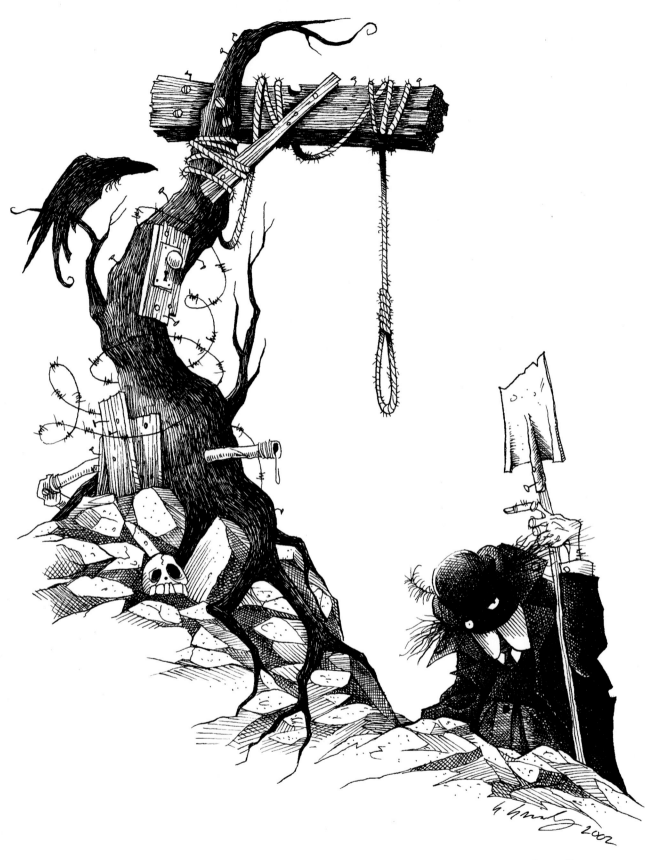

G is for Gallows
ink on illustration board 2002

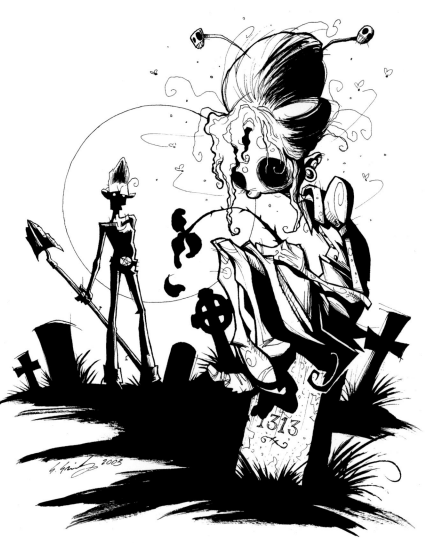

The Unconventional Amour
ink on illustration board 2003

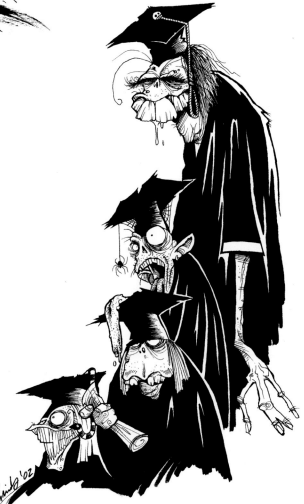

Ghoul School
ink on illustration board 2002

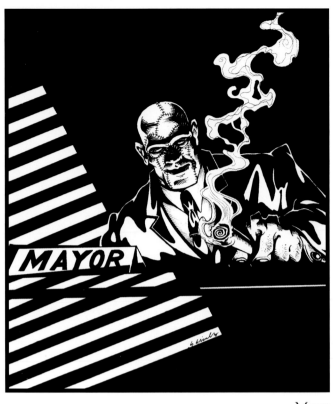

Mayor

ink on illustration board 2001

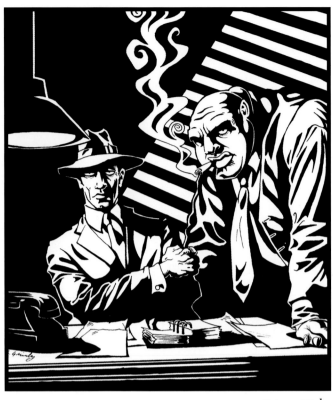

Private Dicks

ink on illustration board 2001

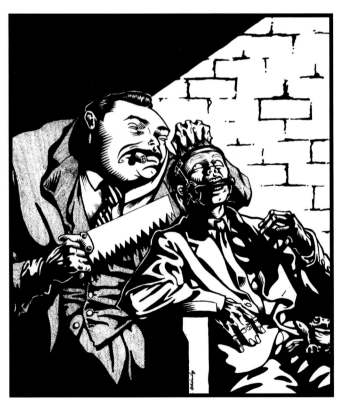

Frog Legs

ink on illustration board 2001

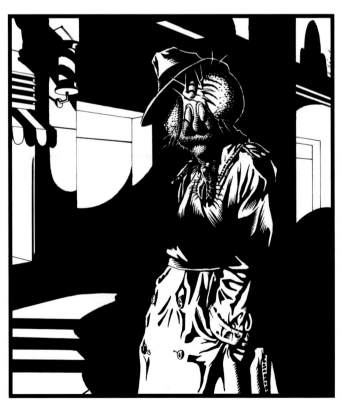

Fly Guy

ink on illustration board 2001

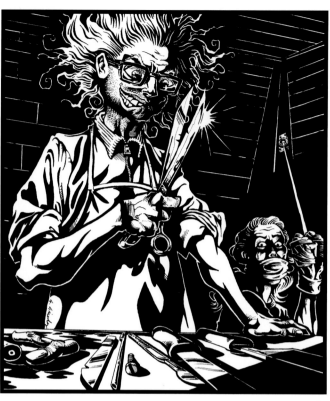

Natas Pringle

ink on illustration board 2001

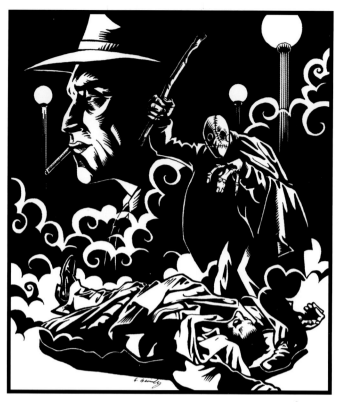

Shaman

ink on illustration board 2001

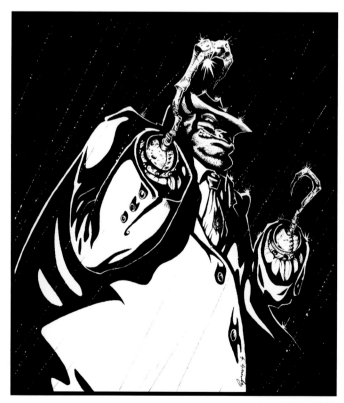

Louie Hooks

ink on illustration board 2001

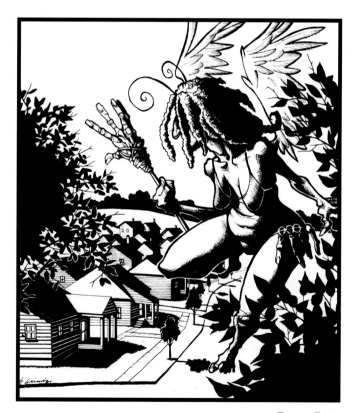

Finger Fairy

ink on illustration board 2001

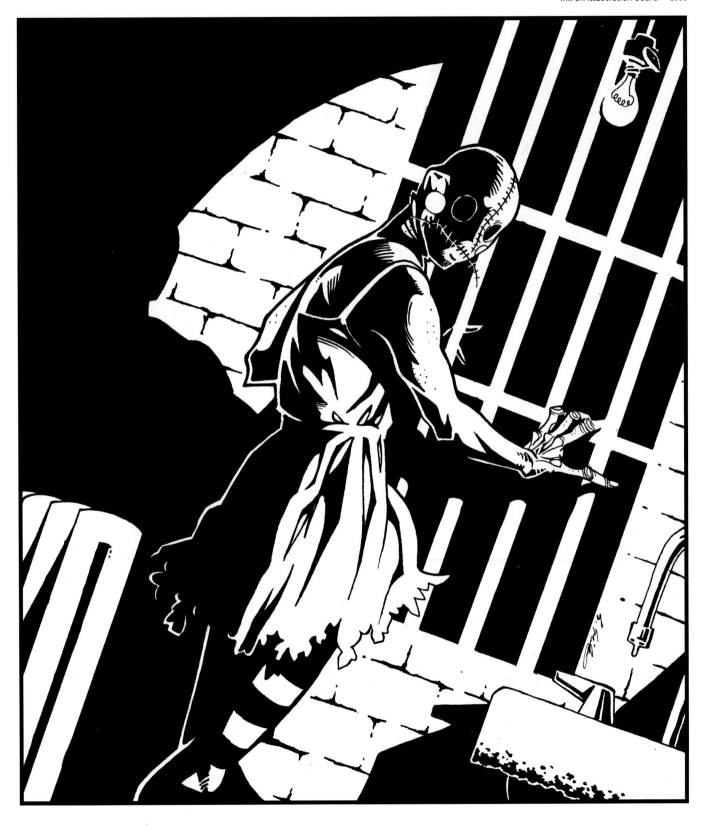

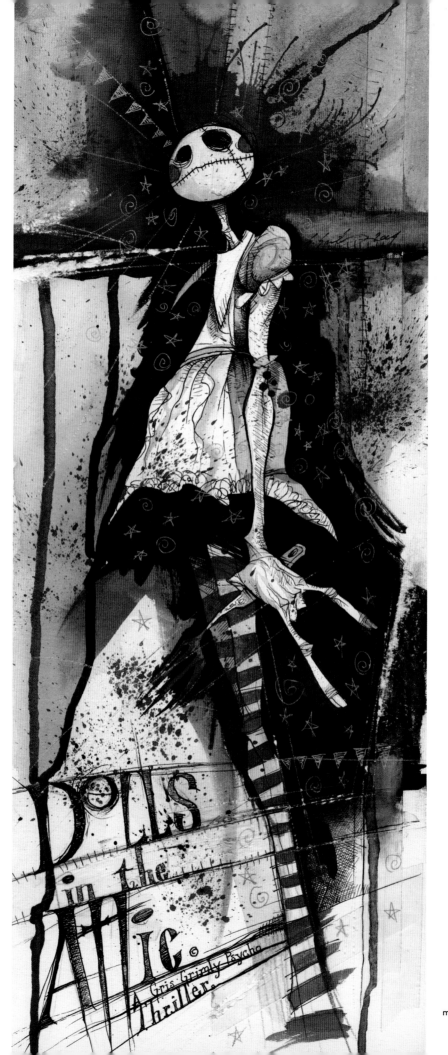

Insanity Painted in
Crimson and Nicotine
mixed media and collage on board
2004

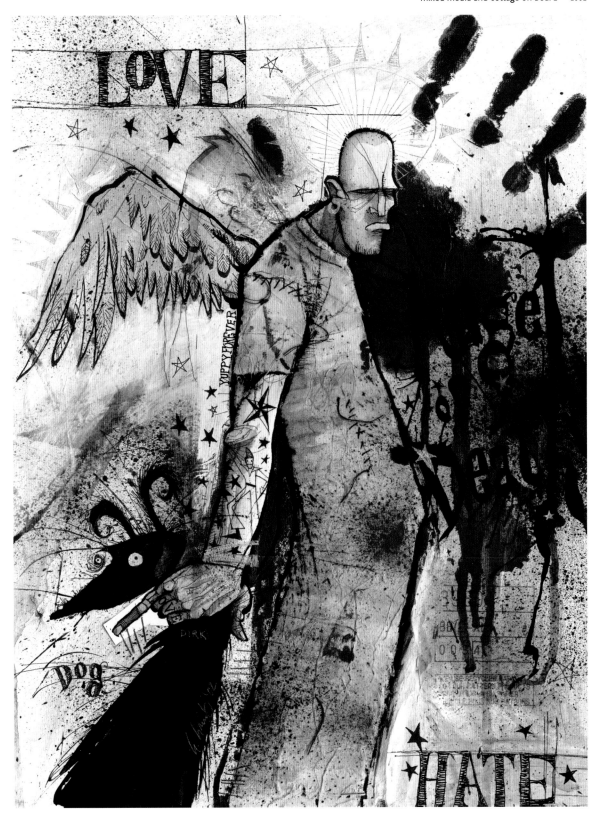

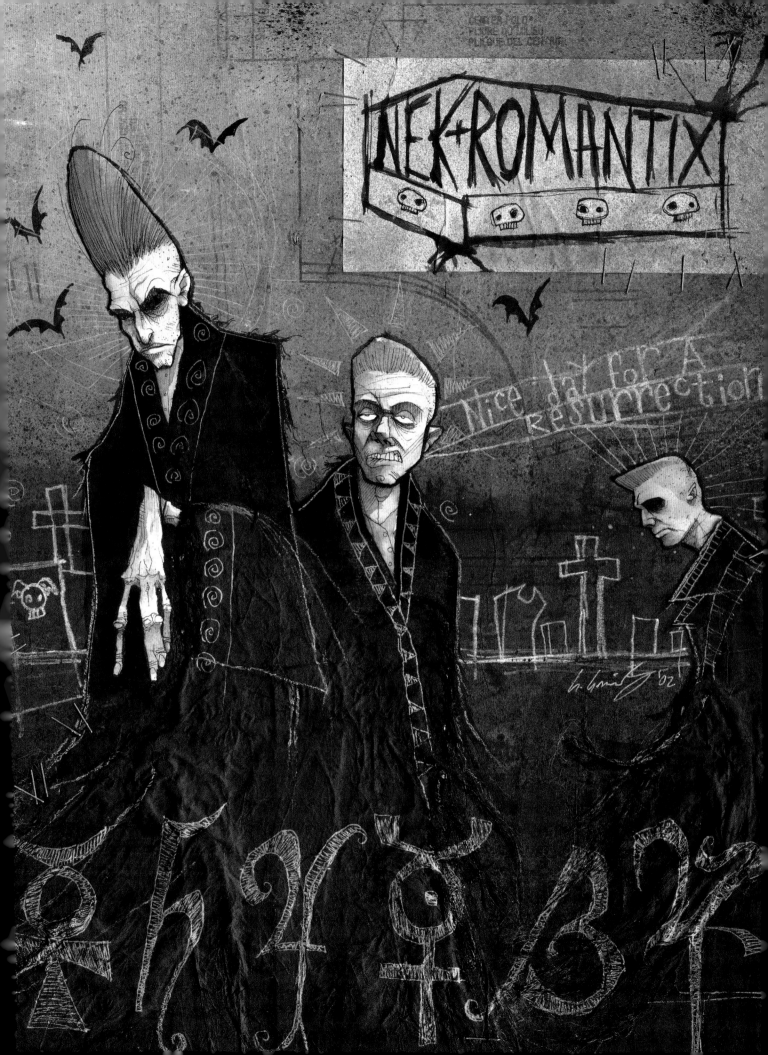

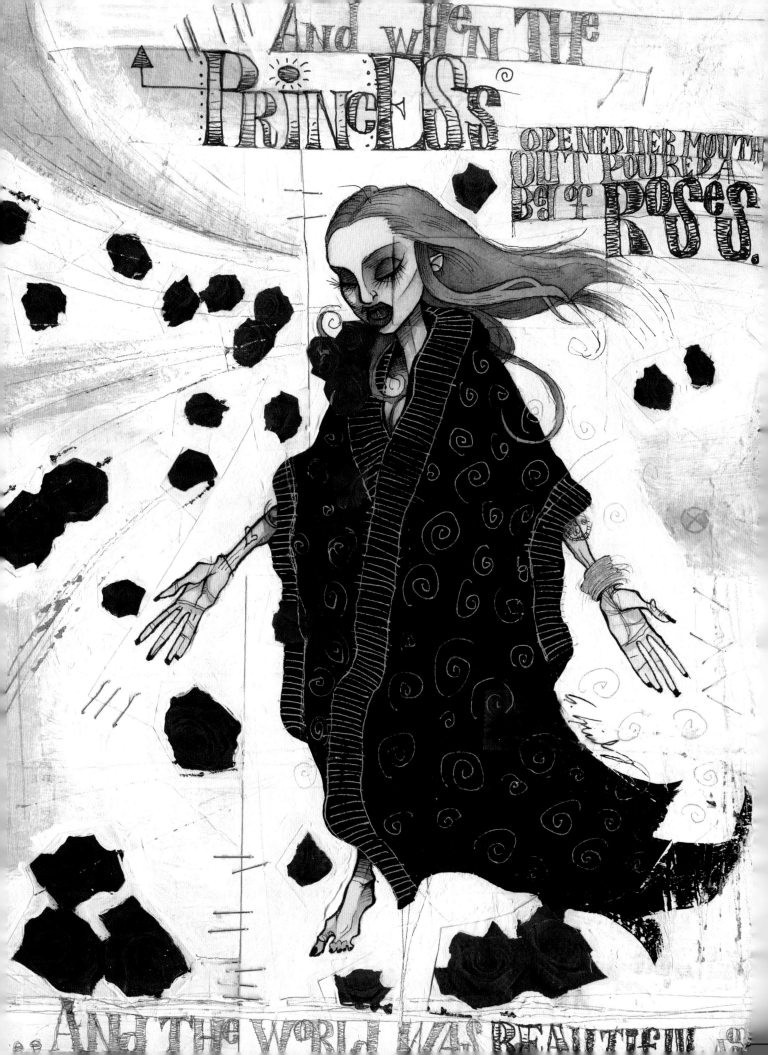

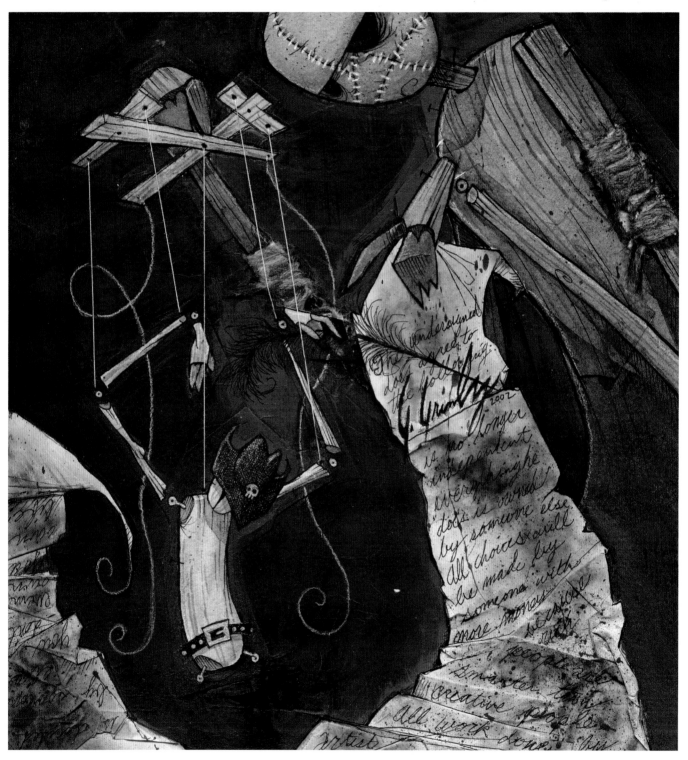

The Purging of the Roses
mixed media and collage on board 2003

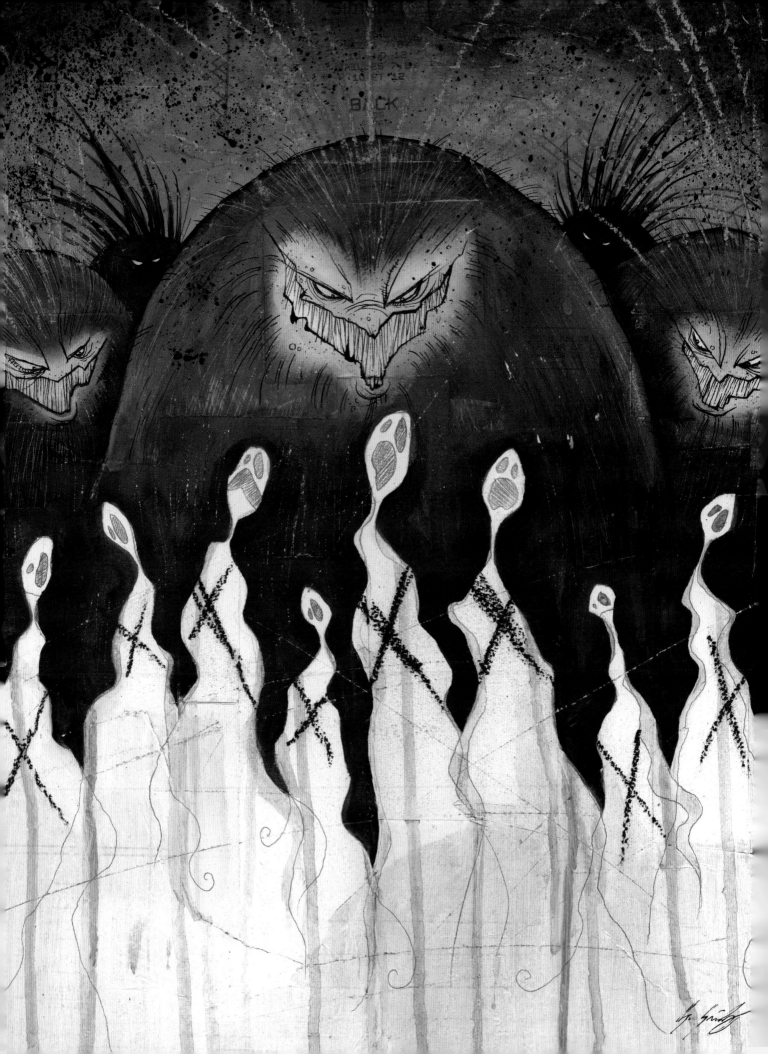

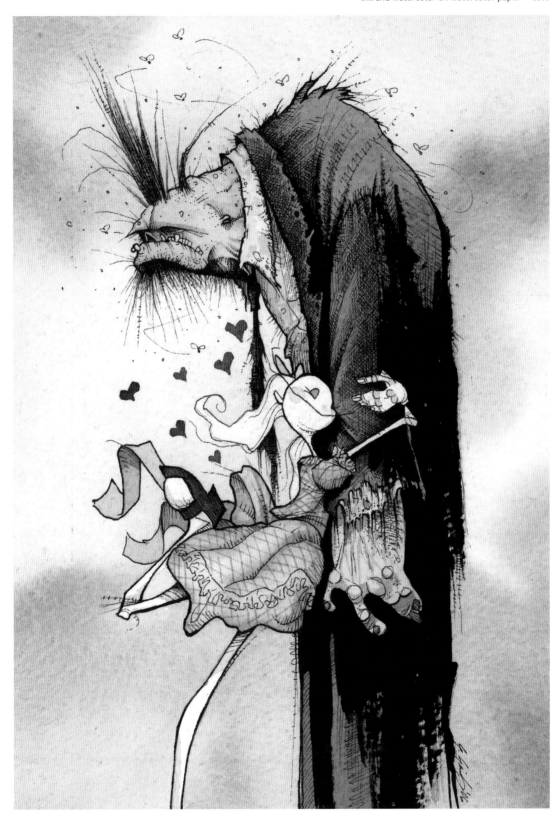

Sunset Souls for the Taking
mixed media and collage on board 2006

The Adventures on Halloween Island
ink and watercolor on watercolor paper 2006

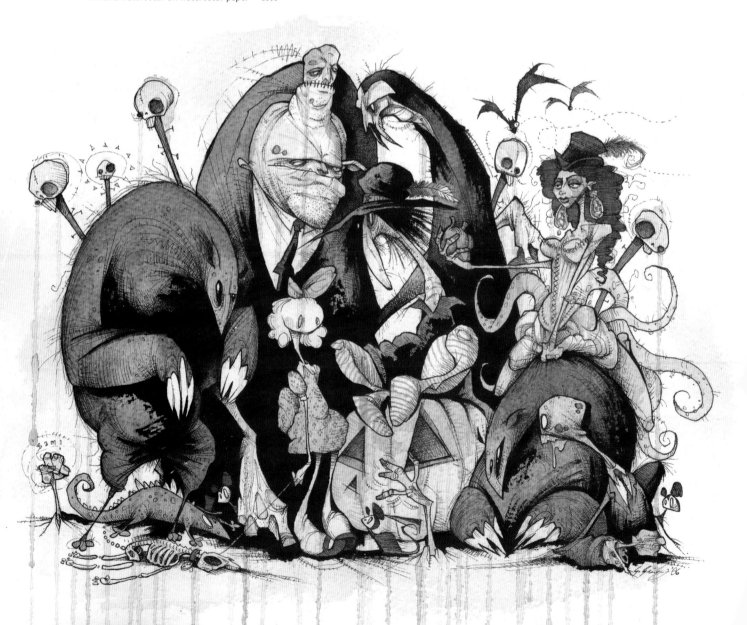

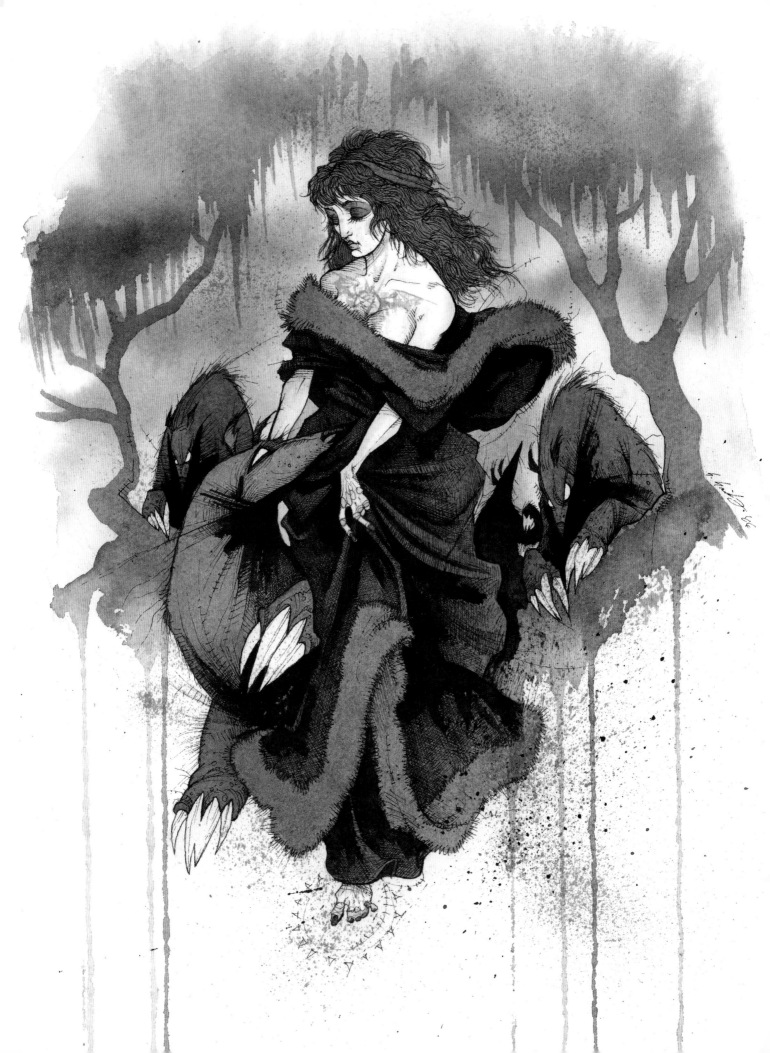

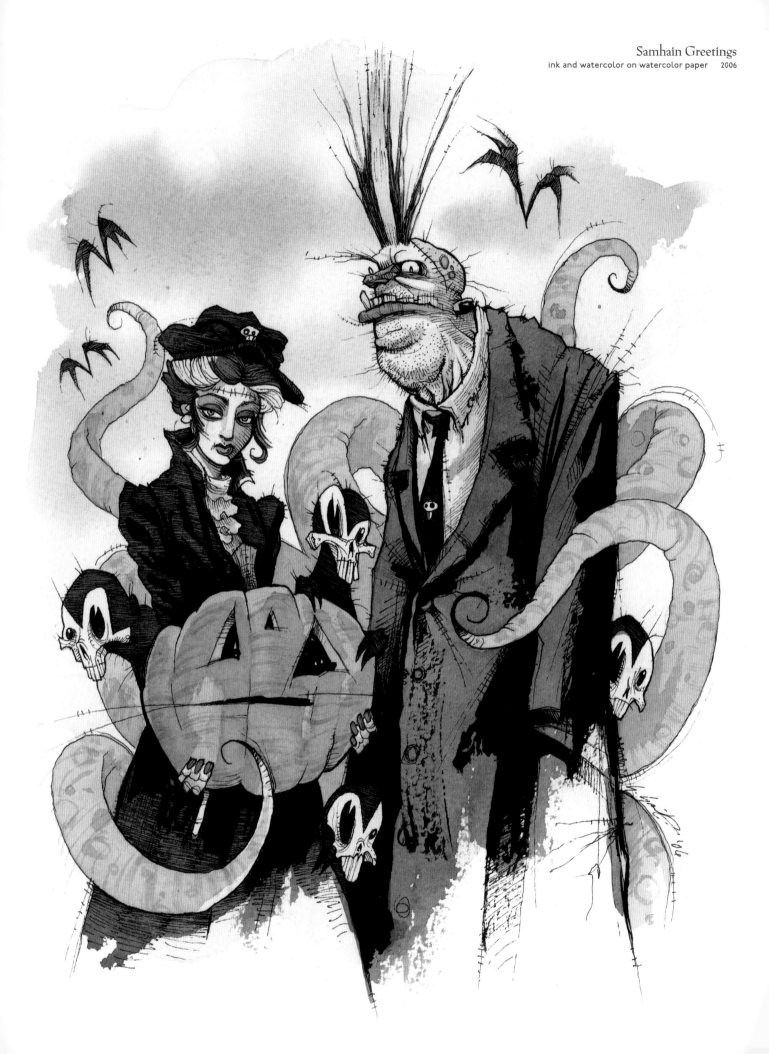

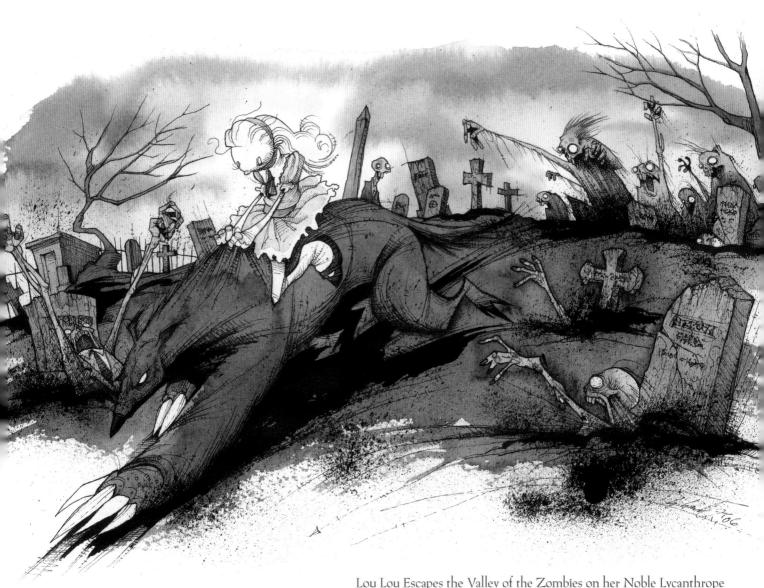

Lou Lou Escapes the Valley of the Zombies on her Noble Lycanthrope
ink and watercolor on watercolor paper 2006

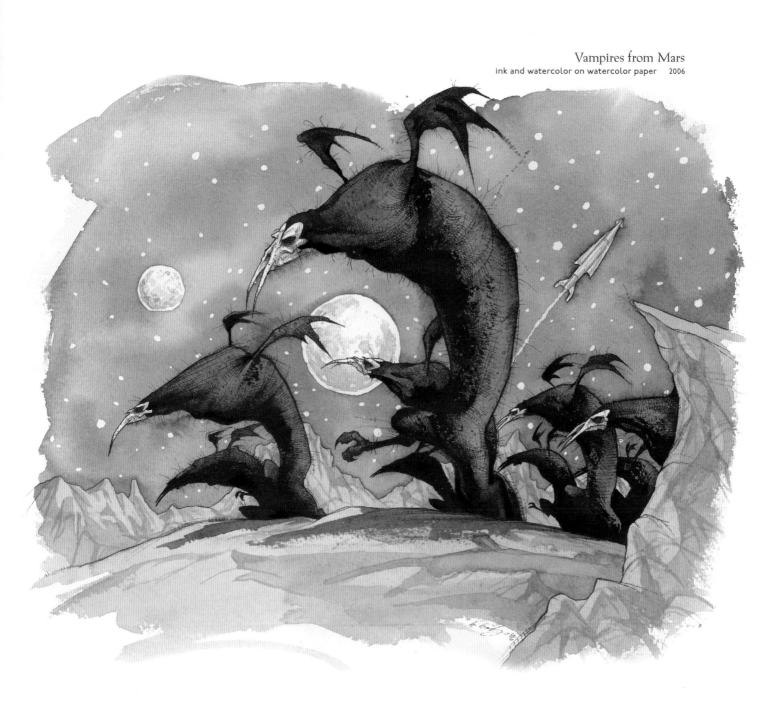

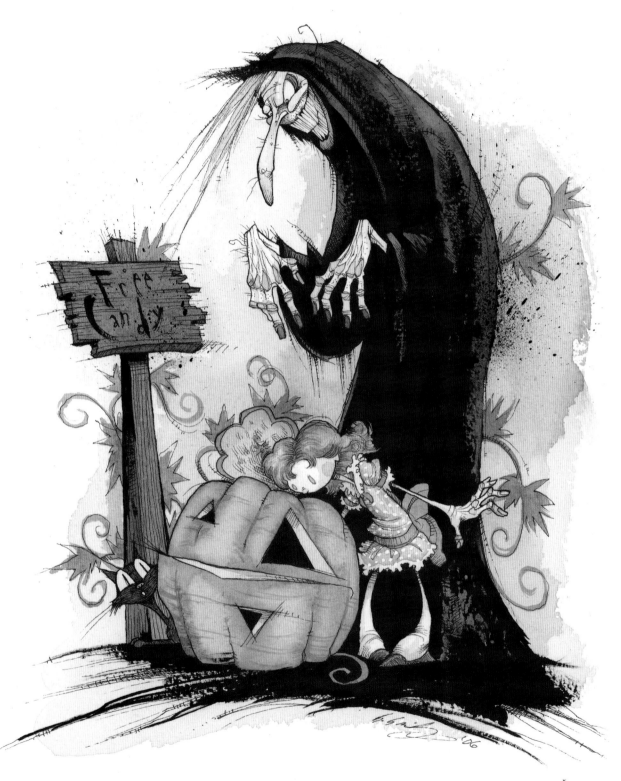

Lure
ink and watercolor on watercolor paper 2006

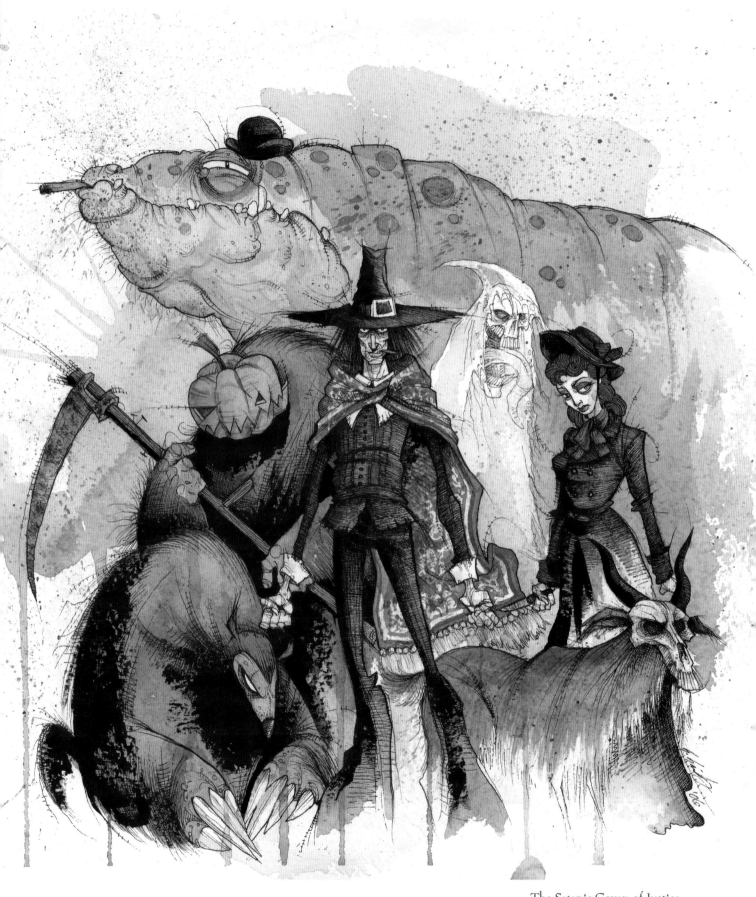

The Satanic Coven of Justice
ink and watercolor on watercolor paper 2006

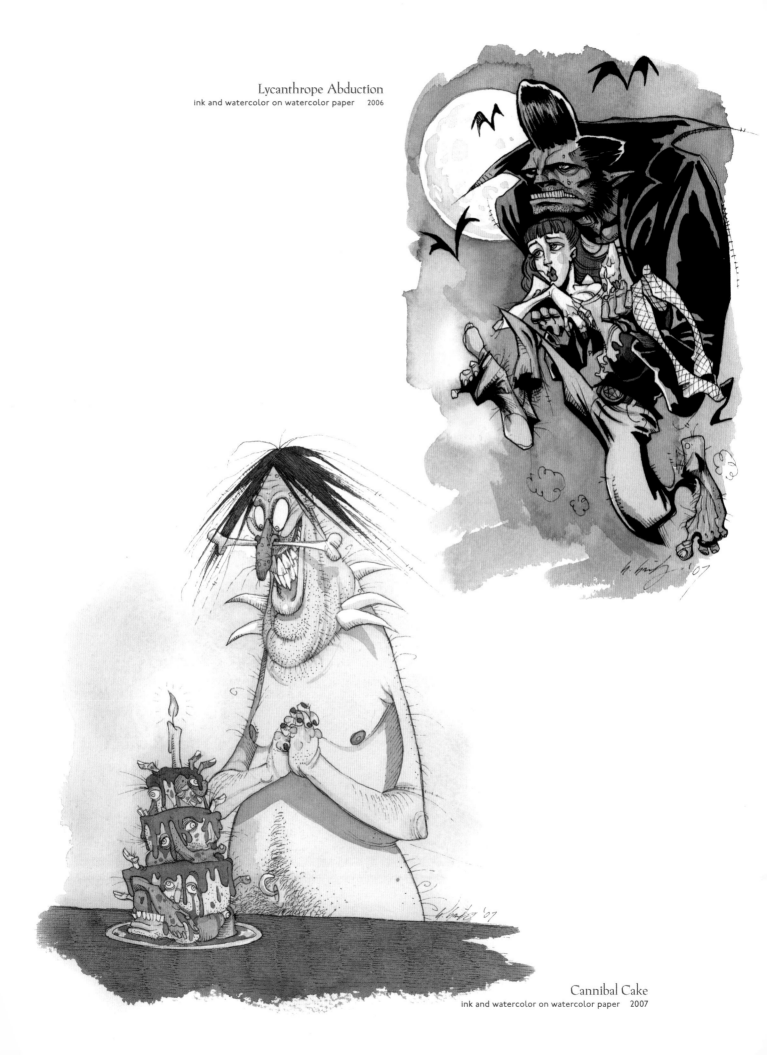

Lycanthrope Abduction
ink and watercolor on watercolor paper 2006

Cannibal Cake
ink and watercolor on watercolor paper 2007

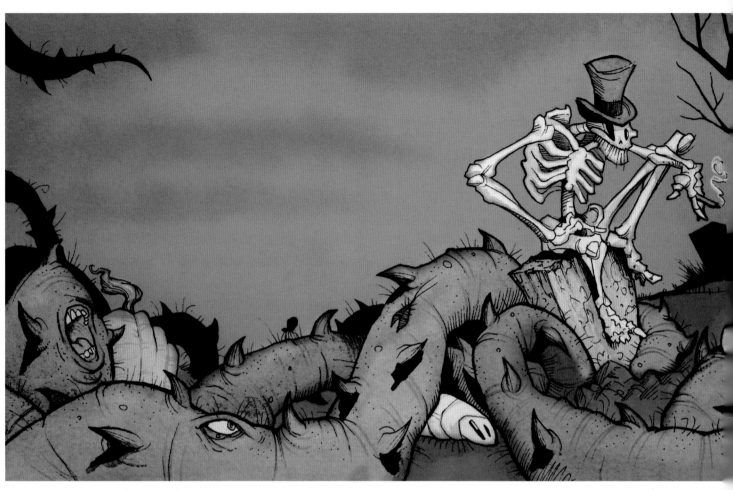

Mortimer: Ashes to Ashes
ink and watercolor on watercolor paper 2007

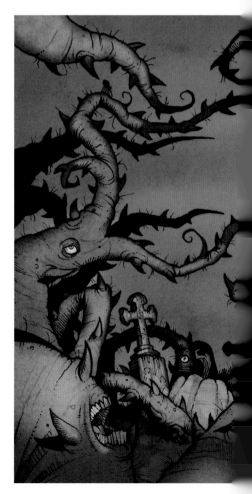

Grue: Bones to Paste
ink and watercolor on watercolor paper 2007

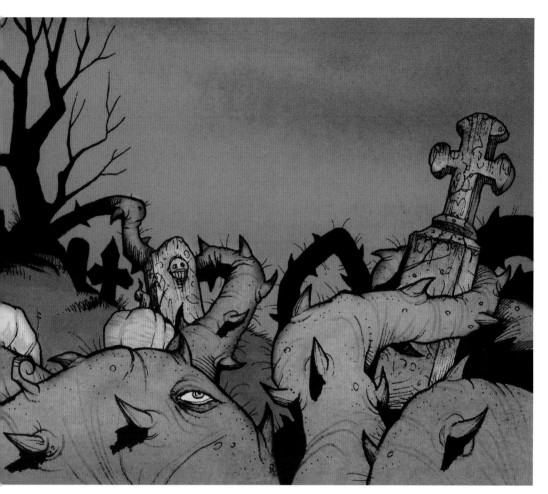

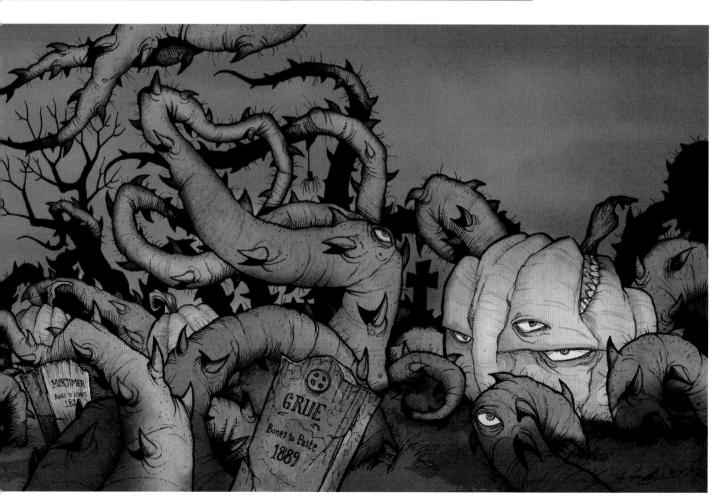

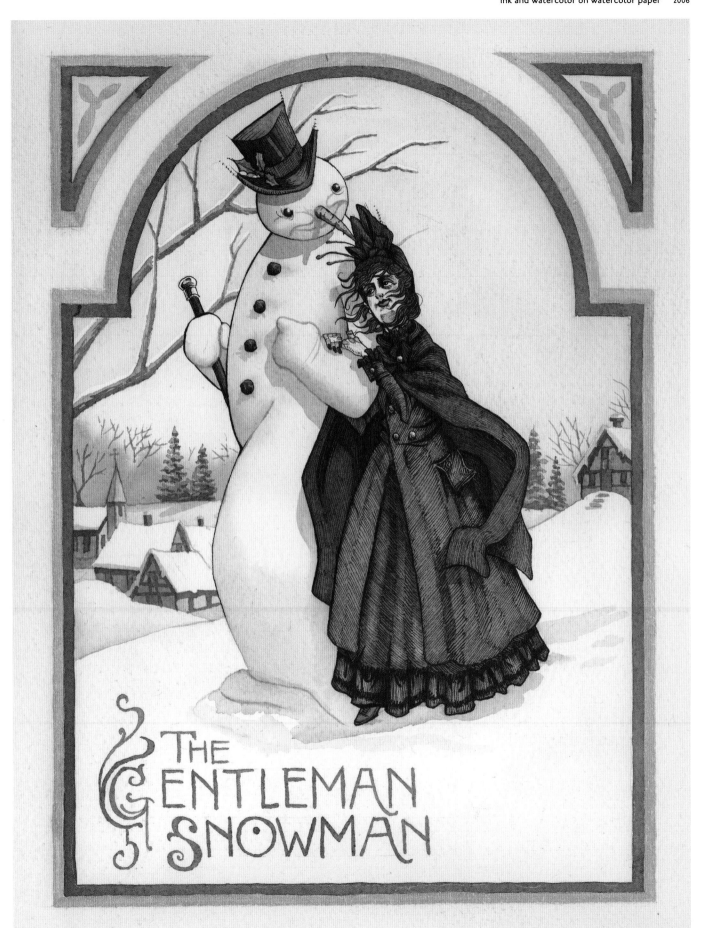

THE
GENTLEMAN
SNOWMAN

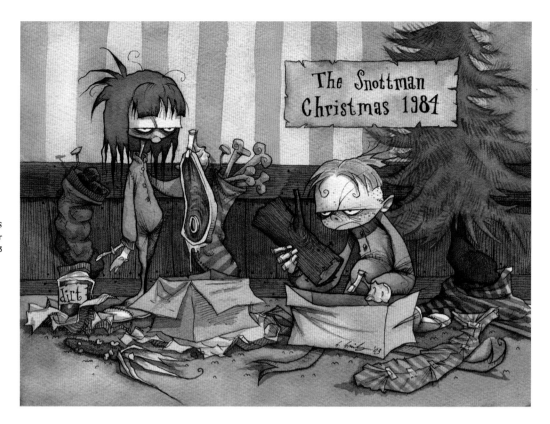

The Snottman Christmas
ink and watercolor on watercolor paper
2003

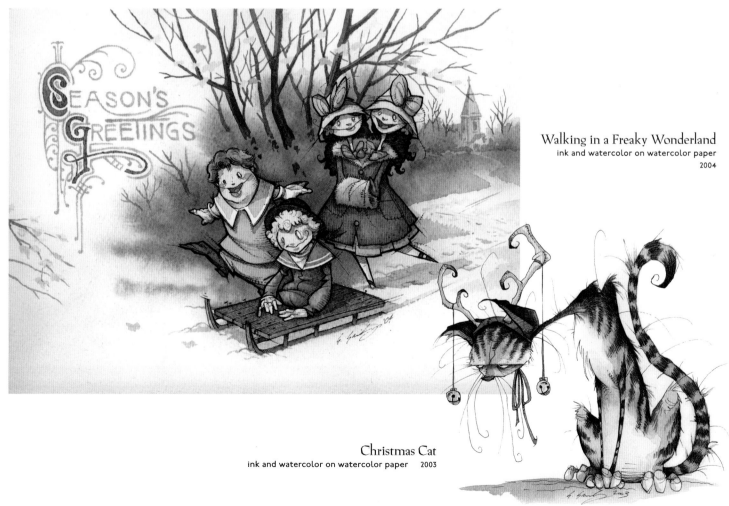

Walking in a Freaky Wonderland
ink and watercolor on watercolor paper
2004

Christmas Cat
ink and watercolor on watercolor paper 2003

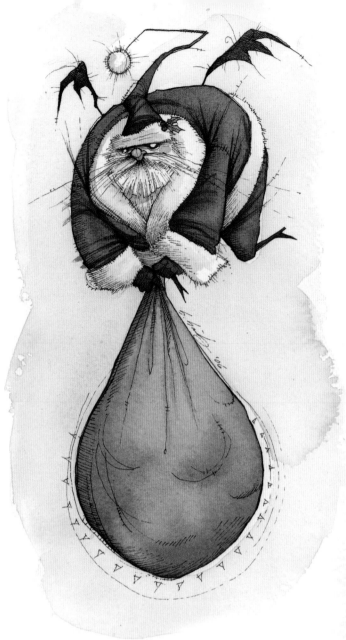

Santa Bat
ink and watercolor on watercolor paper 2006

Red Stains on White Snow
ink and watercolor on watercolor paper 2003

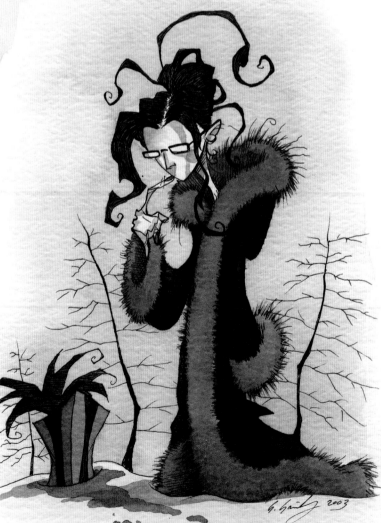

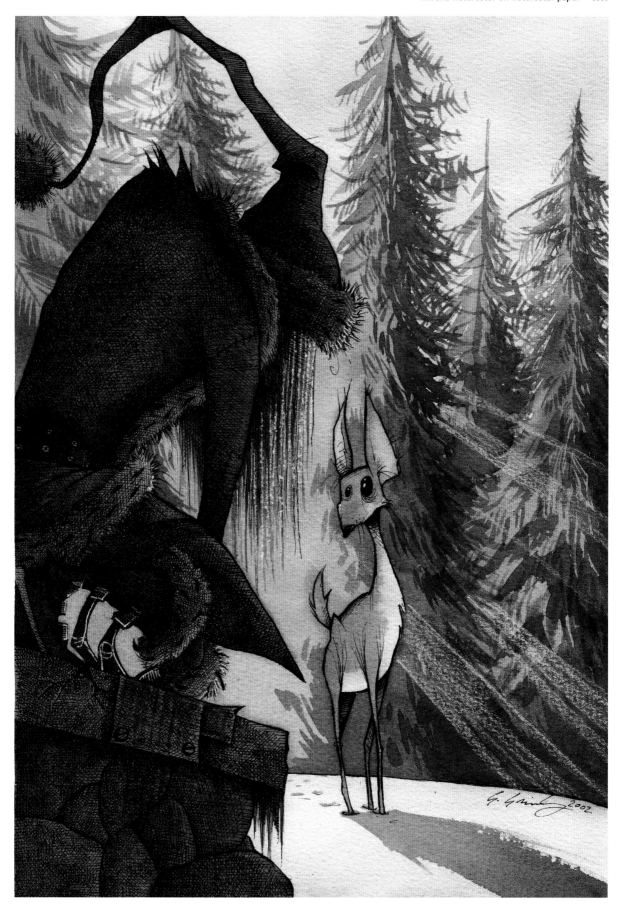

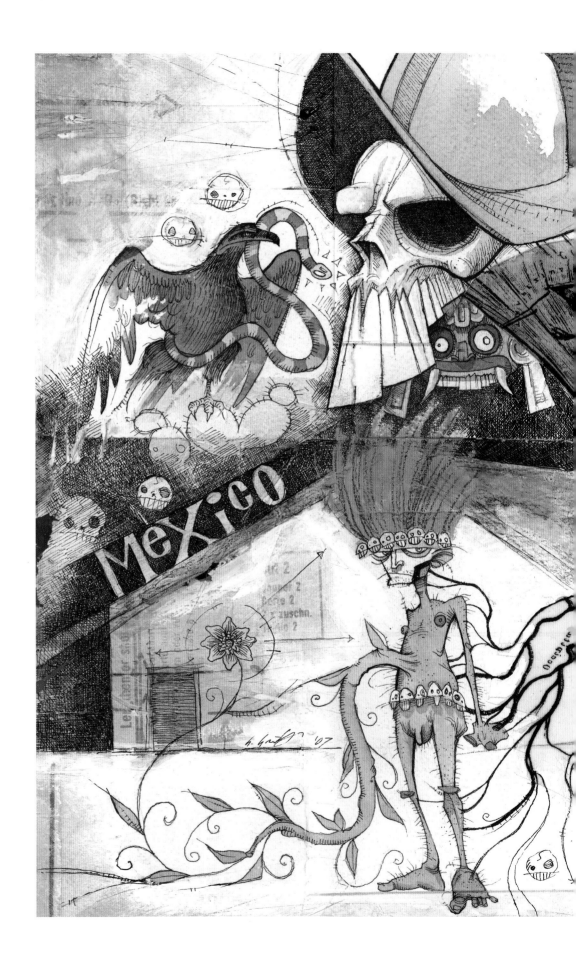

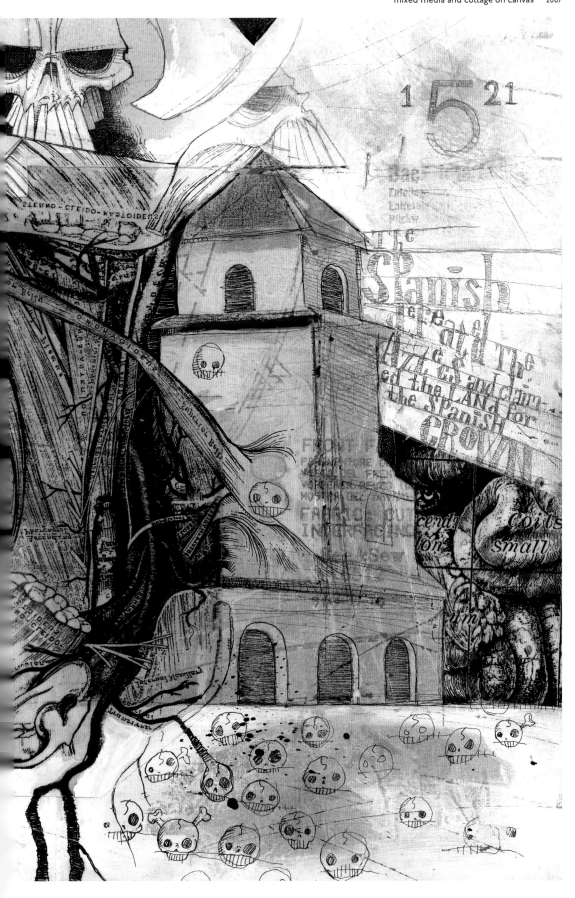

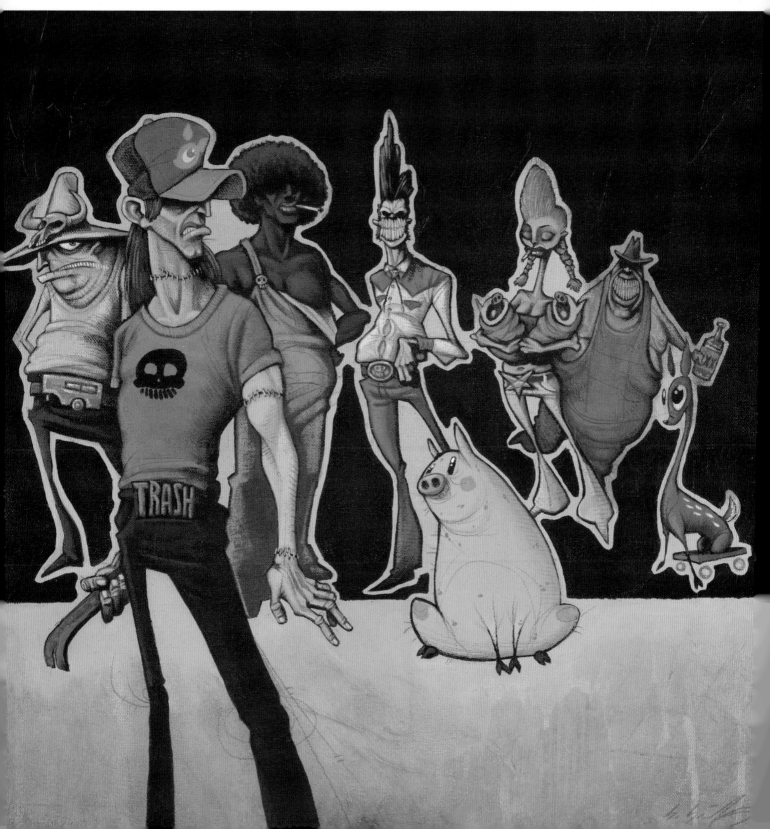

First American Vampire
acrylic on canvas 2007

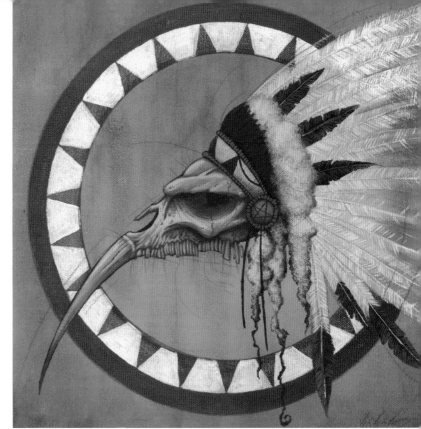

A Redneck Werewolf in America
acrylic on canvas 2007

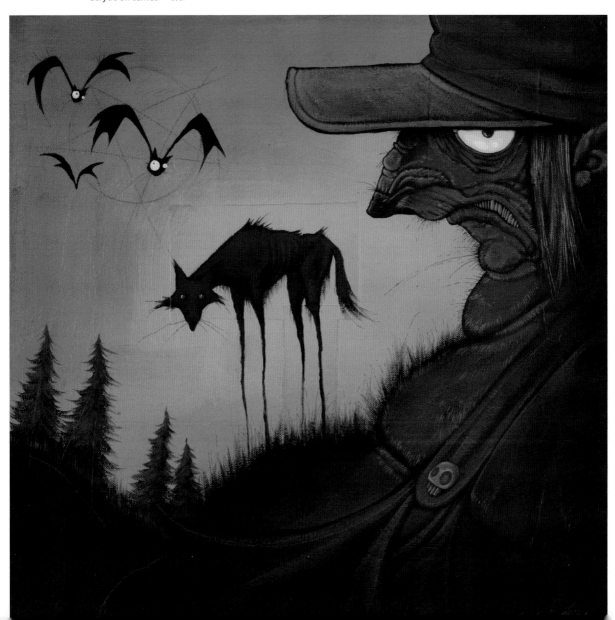

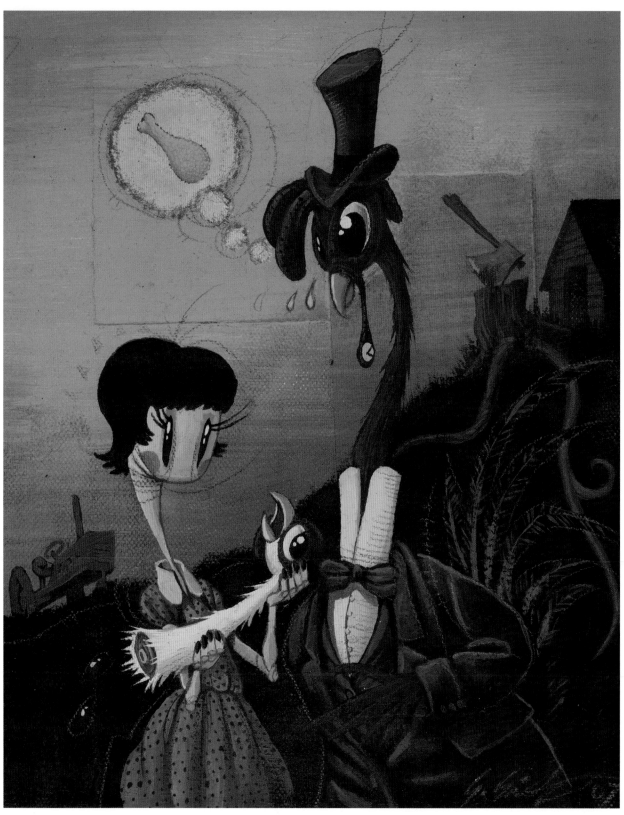

Misfortune Strikes on Colonel Sander's Farm

acrylic on canvas 2007

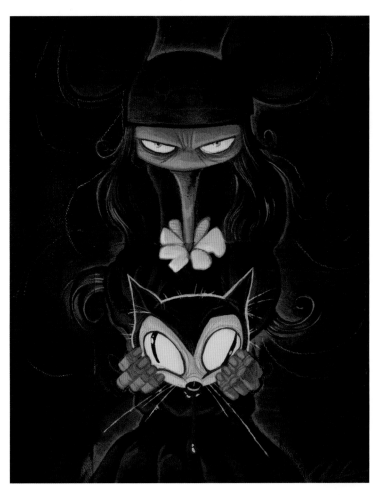

Cat and Mouse
acrylic on canvas 2007

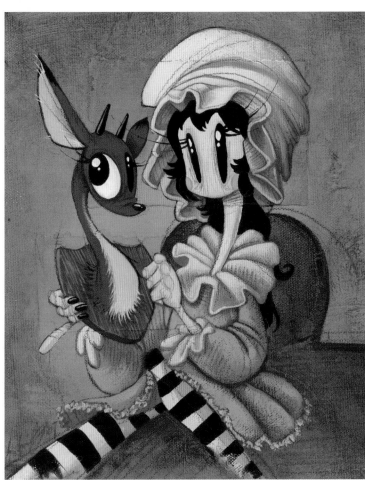

Mindy with Her Pet, Wallmount
acrylic on canvas 2007

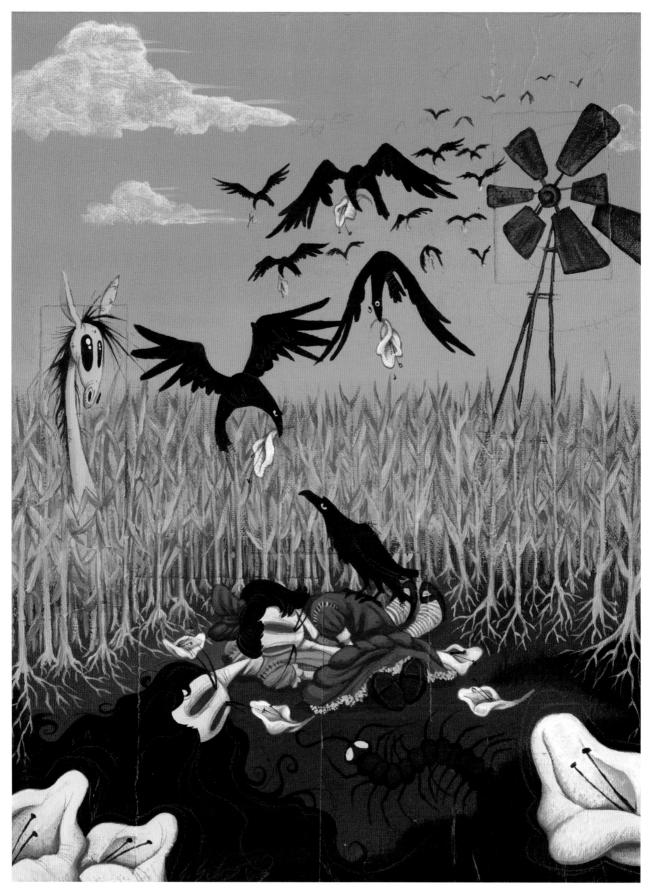

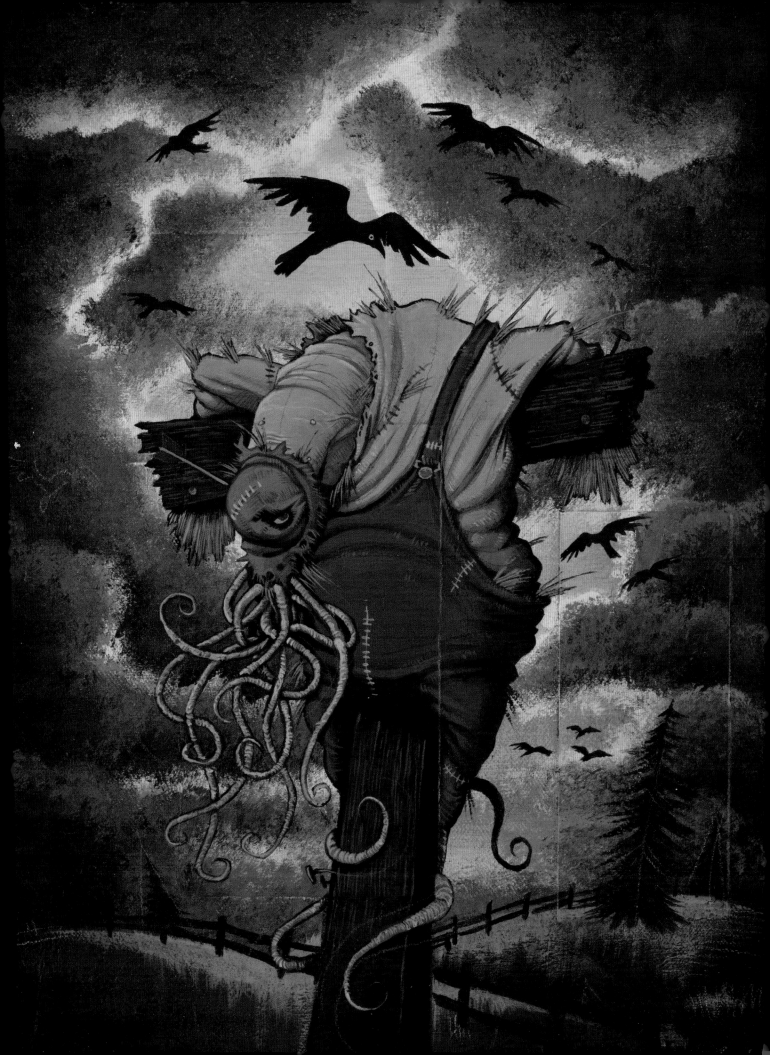

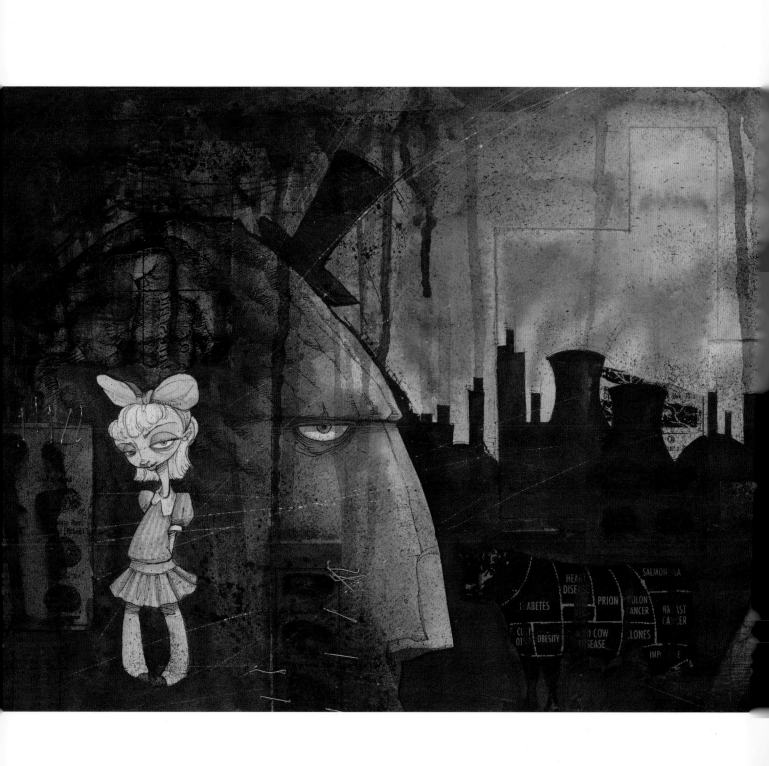

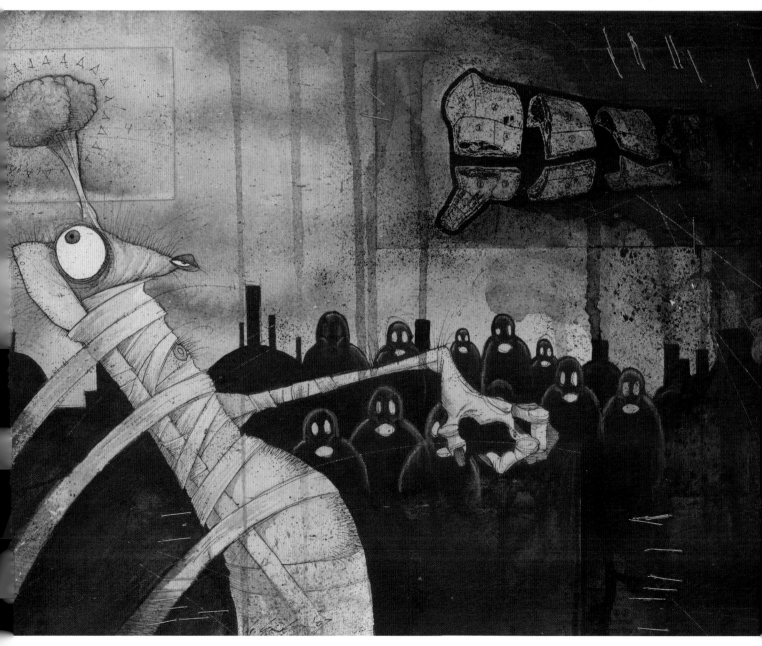

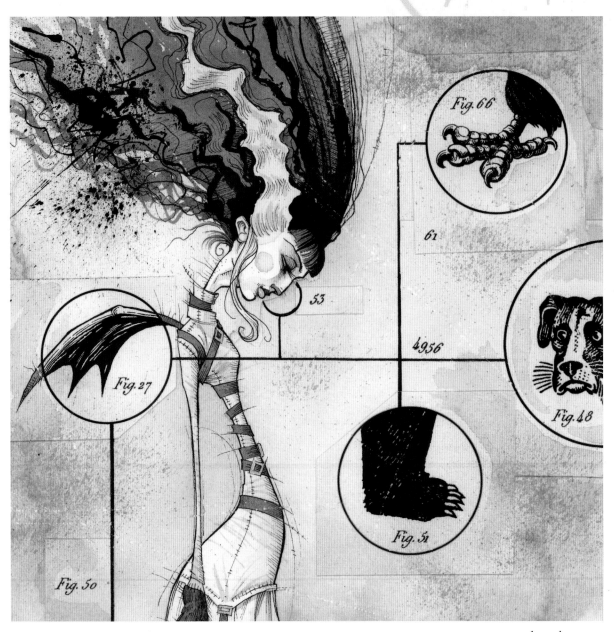

Fig. 66

61

53

4,9,56

Fig. 27

Fig. 48

Fig. 51

Fig. 50

Beauty in the Laboratory
mixed media and collage on board 2007